D0947818

IMAGES
of America

BRENTWOOD

MISSOURI

IMAGES
of America

BRENTWOOD
MISSOURI

Brentwood Historical Society

ARCADIA

Published by Arcadia Publishing,
an imprint of Tempus Publishing, Inc.
3047 N. Lincoln Ave., Suite 410
Chicago, IL 60657

Printed in Great Britain.

Library of Congress Catalog Card Number: 2002109226

For all general information contact Arcadia Publishing at:
Telephone 843-853-2070
Fax 843-853-0044
E-Mail sales@arcadiapublishing.com

For customer service and orders:
Toll-Free 1-888-313-2665

Visit us on the internet at http://www.arcadiapublishing.com

This book is dedicated to the tireless efforts of Anne Schall, Hazel Rekart, Lorraine Krewson, Barbara Gill, and Regina Gahr.
Anne Schall over many years collected and filed photographs and history notes of the Brentwood area until her death in 1984. Hazel Rekart, Lorraine Krewson, and Barbara Gill were prime movers in the creation of the Brentwood Historical Society in her honor. Regina Gahr has been a strong force in its continued existence.

CONTENTS

Brentwood Historical Society Members
as of June 9, 2002

Joseph E. Gill - President
Nancy Burris - Vice President
Regina Gahr - Secretary
Lorraine Krewson - Treasurer

Charles Ault
Gladys Barlow
Richard Brantley
Earl and Joyce Brown
Jill Brown
John Cleary
Jim Curtin
Gene Dodel
Keith Dodel
Betty Edelman
Charlotte Ellis
Jim Fiete
Dan Fitzgerald
Dave Fitzgerald
Barbara Gill
Betty Gore
Pat Harris
Nancy Jones
Pat Kelly
Karen Kintz
Tom Kramer

Denise B. Lee
Sheila M. Lenkman
Mike Marshall
Constance McNeil
Evelyn Mehler
Patti Nations
Keith Rabenberg
Bonnie Rasmussen
Ann and David Reckelhoff
Keith Robertson
Barbara Roth
Chris Seemayer
Bob Shelton
Peggy Smith
June Strassner
Shawn Tucker
Evelyn White
Sue Willams
Lee Wynn
Matt Zavac

ACKNOWLEDGMENTS

Information and photos included in this publication have been drawn from the Brentwood Historical Society files, family photo histories, and the *Pulse* newspaper published by Gene Del Printing.

The help in classifying, selecting, and editing material was provided by Regina Gahr, Patricia Harris, Nancy Jones, Lorraine Krewson, and Peggy Smith and is greatly appreciated. Special thanks go to Patti Nations, Lois Hellwege, Karen Kintz, Lou and Edith Brussati, and Ken Koerber for answering our plea for photographs. The work would not have been accomplished without the guidance of Joe Gill, our president.

The students and senior citizens of Brentwood collected many of the historical photos in 1982, under a project funded by a grant from the Missouri Humanities Council. As a result of this activity, a "Living and Learning Center" was established at the high school. It was the only such facility in the state of Missouri. It was closed to make room for the Brentwood pre-school program begun in 1992. The material was then turned over to the Brentwood Historical Society.

Since its beginning in 1985, the Brentwood Historical Society has continued collecting pictures, papers, memorabilia, and oral histories, which may help to establish or illustrate almost 200 years of Brentwood history. These photos reflect the people, places, homes, community activities, and businesses of Brentwood over this period. Many of the locations have been replaced as Brentwood has progressed and moved into the 21st century. This book will help the memories live on.

INTRODUCTION

The history of the area now called Brentwood dates back to 1804 when Louis J. Bompart bought 1600 acres between Litzsinger on the north, Hanley Road on the east, Brown Road (later called North and South and now Brentwood Blvd.) on the west and Lockwood on the South. Later the Marshall family purchased property to the west, and the Gay family purchased property to the north. These purchases completed what is now Brentwood.

In the early 1870s Thomas Madden came to the area and purchased 100 acres for a farm. By 1877, property owners included Brazeau, Moss, Baker, Perry, Madden, Dr. Berry, Phil Berry, Curry, Hackett, and Dr. Warren. Madden became the businessman of the community. He operated a rock quarry and built a tavern, barbershop, grocery store, and blacksmith shop (which Madden later gave to the Catholic Church for its church). The community became known as Maddenville.

Maddenville was one of the original stops on the "Manchester Trail," the trail west that the prairie schooners and mail coaches traveled in the 1800s. Bartold's Grove and Porta's Tavern, both mile houses in the area, were available to westward bound settlers. Mail coaches traveling Brown Road (Brentwood Blvd.) provided passenger and mail service from St. Louis. In 1890 a streetcar line, commonly known as "the Dinky," was constructed between Skinker Road in the City of St. Louis and Maddenville. In 1892 this line was extended southwest to Kirkwood. With rail service by the Missouri Pacific and the development of the automobile, Maddenville in the early 1900s became attractive to many families. Several landowners built homes and sold lots for newcomers.

When Bompart's property became too costly to operate as a farm, it was subdivided into small home sites. The streets were named after the children of the late Louis "Pat" Bompart Sr. Those streets are still in existence today: Louis, Cecelia, Helen, Ruth, and Dorothy.

Another location of interest in Brentwood's history was Howard Place, which was established in 1907. It became part of Evans Place in 1923. It was a small subdivision of Brentwood inhabited by black residents. It had its own churches, a little market, a school, and a sense of unity that survived for 90 years. The main source of income for this small community was a brick company, General Refractories, which was destroyed by fire in the mid-1960s. In 1997 a developer bought this location, and the Promenade shopping center replaced it.

In 1919 the residents discovered that neighboring Maplewood planned an election to annex their town. To avoid annexation and to establish their own school district, the residents decided to incorporate as a village. Maddenville was officially incorporated on December 15, 1919, and changed its name to Brentwood. The county court appointed a Board of Trustees to serve Brentwood until an election could be held. The trustees were Jacob J. Spratte (chair), Charles Meyer, E.J. Herald, Dr. A. Williamson, and L.N. Webster. Mr. I. Denny was elected clerk of the town.

Between 1924 and 1930 Brentwood had earned an unhealthy reputation due to the

numerous gambling houses and illegal activities mostly located in the areas of Manchester Road and North and South Road (now Brentwood Blvd.). James (Jim) L. "Tex" Willingham became the first mayor of Brentwood (1929–1931). His interest in running for the Mayor's office and what his campaign pledged to do was to clean out the hoodlums and gambling casinos—which he did. By the time he left office, the town was again livable.

On April 12, 1929, Mayor Willingham signed ordinance number 1A, which established the City of Brentwood and described its corporate limits. It also identified wards and ward officers, established the order and procedure of meetings, designated the standing committees and duties of certain officers and committees, and finally, repealed any ordinance in conflict herewith. Walter R. Douglas, the city clerk, attested it. Articles of agreement for a fourth class city with a mayor and six aldermen were signed on Tuesday, March 24, 1931. In 2002 there are now four wards represented by two aldermen each, one coming up for election each year.

Brentwood is small in terms of size, covering an area of 2.5 square miles and 1,394 acres. Although there are now shopping centers, modern office buildings, and many small commercial businesses, Brentwood still has a small-town atmosphere. It has an excellent school district and several churches. The City provides many services: an outstanding police and fire department; a public works department; a public library; a park and recreation department that maintains an ice skating rink and community center as well as several parks. Those who grow up in Brentwood stay to raise their own families. Many of its residents are descendants of the early settlers of Maddenville. Houses are never for sale long, as many people long to call Brentwood their home.

One

WHERE WE LIVE

Prior to 1919, Brentwood was known as Maddenville, named after Thomas Madden. This map from 1904 shows Maddenville, Bartold, and Mentor, which were all stops for the railway. Most of the original homes in Brentwood built prior to 1919 are now gone, but a few are still in existence today. The community has several homes built around the time that Brentwood was officially made a village in 1919. These homes have stood the "test of time." Most of them have been updated and renovated both inside and out, but if you look closely, the charm of an earlier era is still evident. New homes and condominium/townhouse developments have also joined the old. The following photos illustrate the development of Brentwood and its homes, from the past to the present.

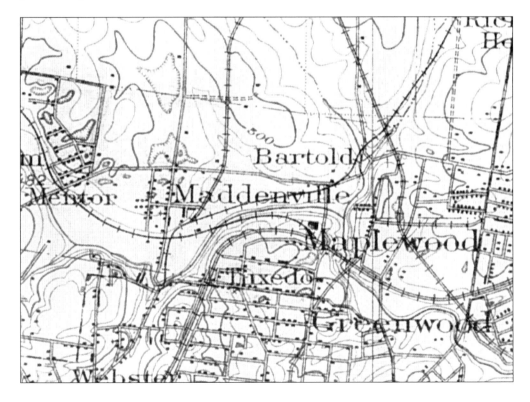

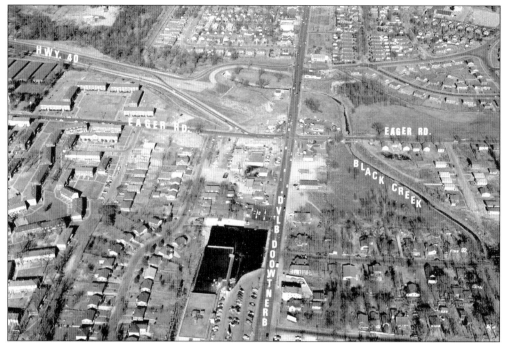

This aerial view shows Highway 40 ending at Eager Road and Brentwood Blvd. in 1955. Highway 40 was improved from the west to the east. It stopped at Brentwood Blvd. while sections to the east were completed.

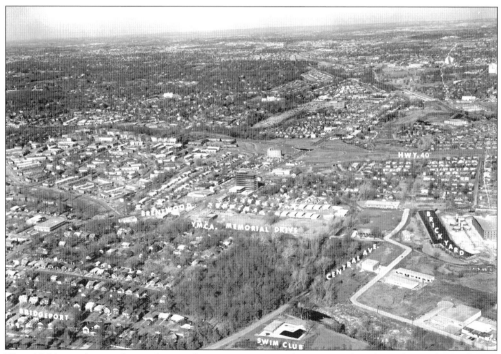

This 1964 aerial view shows the northeastern section of Brentwood with Richmond Heights to the north.

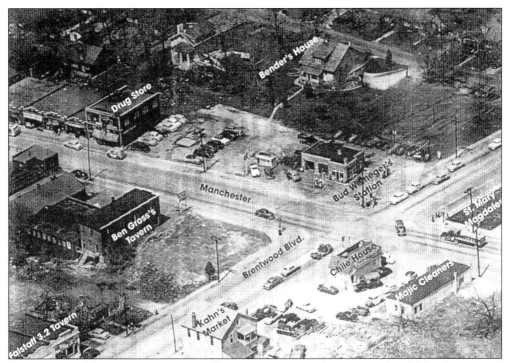

Businesses and homes are shown in this aerial view at the crossroads of Manchester and Brentwood Blvd. in 1953.

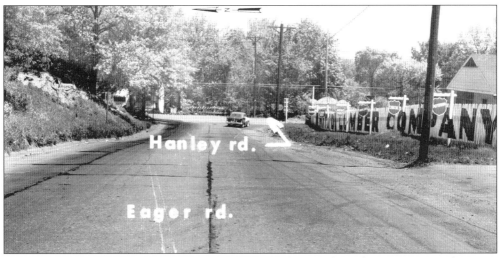

Shown in 1955, Eager Road dead ends at Hanley Road. United Lumber Company is shown on the right.

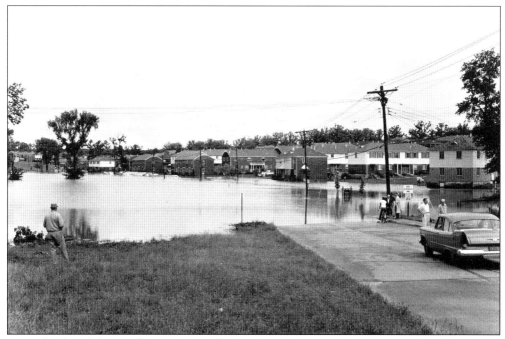

Rains flood Audubon Park at Wrenwood on June 14, 1957.

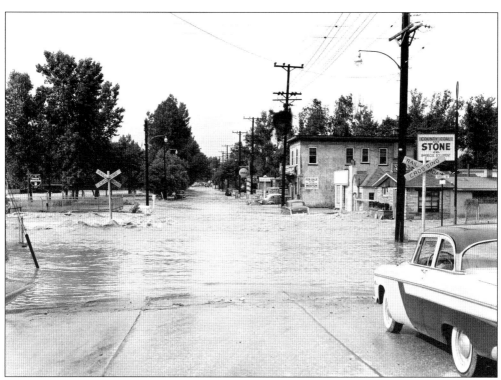

Pictured is a flood in June 1957, at Brentwood Blvd. and Russell Avenue.

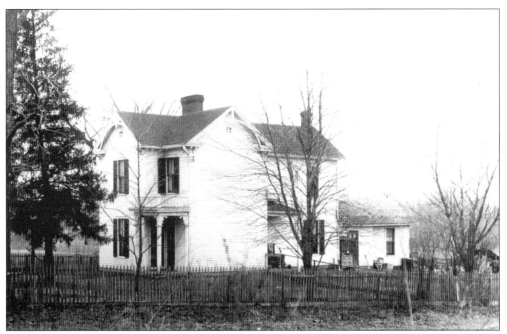

The Moritz Homestead, c.1922, at the northwest corner of White Avenue and Brentwood Blvd. was built in 1880. This home was eventually torn down, and the property is now occupied by retail establishments.

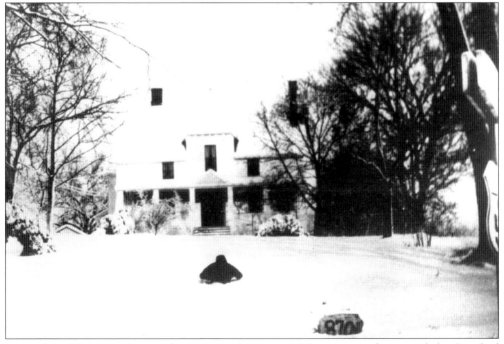

Located at 8701 Manchester, the Bompart home, c. 1892, was torn down, and the Stanford Place II apartments located on the site.

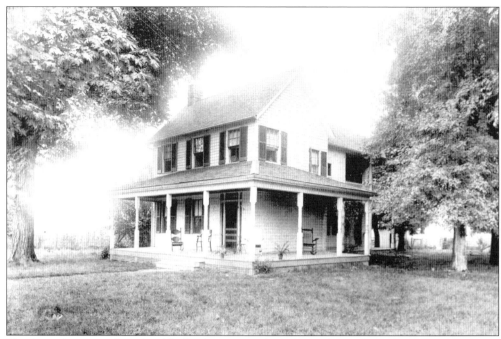

The Moss home in the 2500 block of Brentwood Blvd. was located on the original Bompart property. This view dates from around 1900. A strip mall is now located on this site.

The current owner of this home at 8828 Pendleton, built in 1904, is Bonnie Rasmussen. This home was ordered direct from the Sears & Roebuck catalog. All the building materials and instructions for assembly were shipped by rail. Bonnie has maintained this home as close to the original as possible.

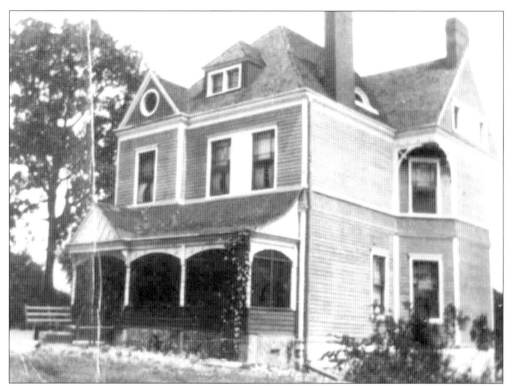

Pictured here is the William N. Jones home, located at Litzsinger and Lay (now McKnight Road) as it appeared in the 1920s.

The White home (Litzsinger at Brentwood Blvd.), built prior to 1919, has a tennis court and is still occupied by a White family member.

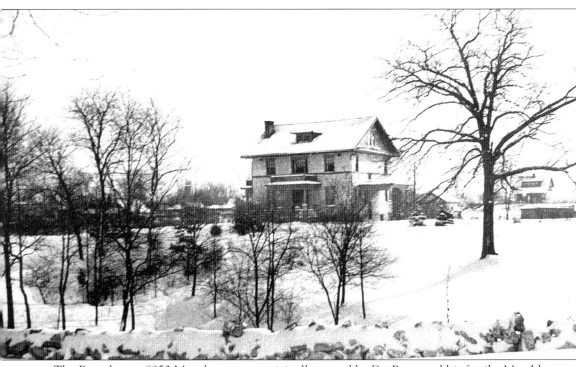

The Berry home, 8950 Manchester, was originally owned by Dr. Berry and his family. Mrs. Ida Tammany and Mr. and Mrs. I. Wm. Schlerech owned and lived in the home from 1919 to 1925. There was a stone gate driveway on the right, which is not included in the pictures. The entrance to "Berry's Cave" is in the left foreground amid the cluster of trees. The entrance to the cave was sealed off many years ago.

The cave was a popular "playground" for the boys of Brentwood in the early 1900s. Jim Kalb, a long-time Brentwood resident, recalled "Berry's Cave" as a haven for kids, especially on rainy Saturdays. "We could walk south about 200 feet in a low area called a sink hole. At the bottom was the entrance, which went into a room about seven feet high and maybe ten feet in diameter. There was a crevice on the south side that we could see into with a light, but we could never figure a way to get into it. To the north we could go a long distance. This would take you through crevices that you had to squeeze through and areas you had to crawl through. The cave had rooms or areas from three to seven feet high. We could see small stalagmites and stalactites in the larger rooms. They were, however, too small to be knocked loose. The only outlet we ever found in exploring the cave was on Brentwood Boulevard (then North and South Road). The outlet was in the form of a large sewer pipe that was imbedded in one side of the quarry located on the Moss property where the Kimberly Building is currently located."

In 1927 Joseph and Olla M. Gray with their daughter Maxine moved into the Warren home at 8822 Powell Avenue. It was known by Brentwood residents as the "Haunted House." Maxine tells us, "I do not know why, but there were always doors slamming or strange noises quite frequently and kept me frightened." However, Maxine says that "living there was a wonderful experience, never to be forgotten."

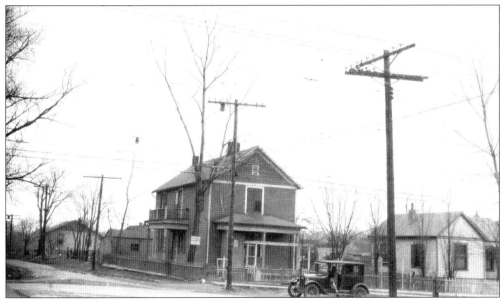

The Schulte home was built in 1905 at 1040 North and South Road (now Brentwood Blvd.). It is pictured here in 1910 with a new model T Ford in front.

This stucco home at 2641 Cecelia was built prior to 1919 and reflects the varied housing styles of the early 1900s.

Built prior to 1919 and located at 2912 Brentwood Blvd., this home is currently a commercial property.

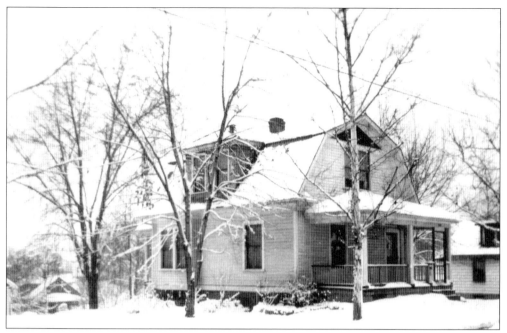

Pictured here is the home of William and Mary McManis at the southwest corner of Cecelia and Florence, built prior to 1919.

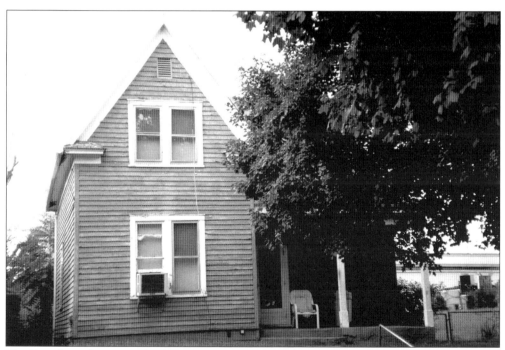

The Dougherty home was built prior to 1919 and is located at 8815 Madge.

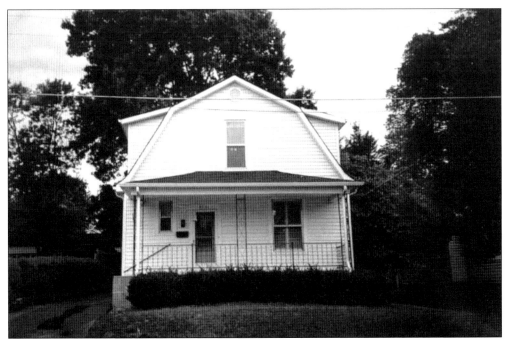

This "barn" style home appears to be the most popular style of architecture built in Brentwood between 1900 and 1920 that is still viable housing stock. Most of these homes have been renovated and remodeled. The home pictured is at 8751 Rosalie.

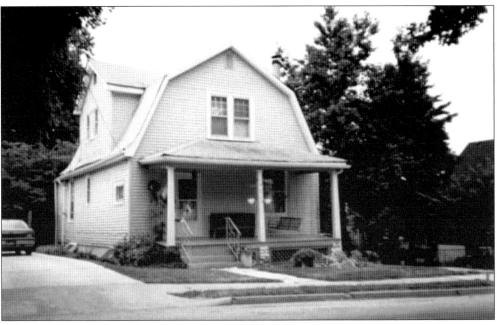

This home, built prior to 1919, is located at 8744 Rosalie.

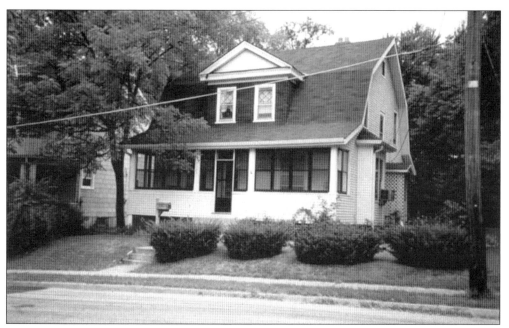

This home, built prior to 1919, is located at 8703 Rosalie.

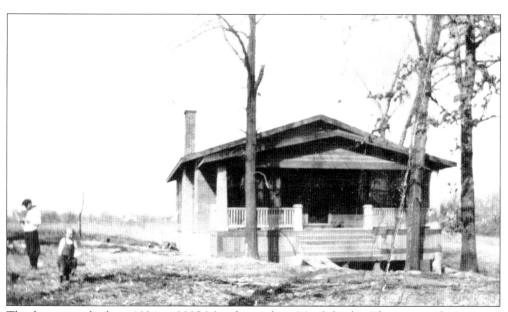

This home was built in 1924 at 9005 Manchester by a Mr. Schinke. There was a driveway on the right side of the house and the garage under the rear of the house. There was a creek next to the drive running toward Manchester. The area is now occupied by the Brentwood Bowling Lanes.

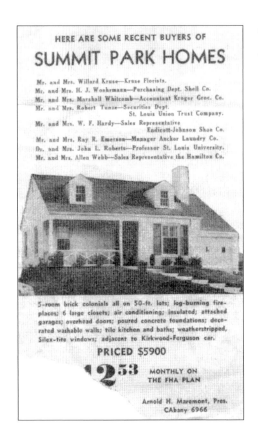

This ad reflects the homes in Summit Park Addition, in the 8600 block of Eulalie Avenue in 1937.

Gerald R. and Mary M. Stimson bought this home at 2330 Hilton Avenue in 1940. It was the display home for the subdivision and was advertised as follows: "Brick construction, 6 rooms: LR, DR, K, 3 BR, 1 BA, WB fireplace, Bsmt garage, Cost: $6,500."

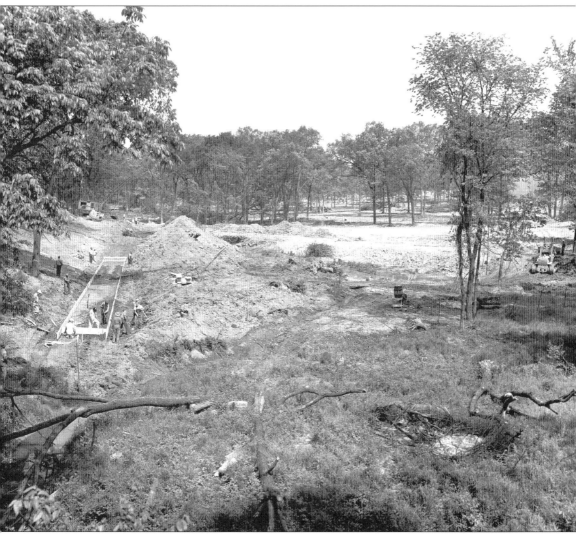

In 1948 Shelby Construction Co. of New Orleans, Louisiana, purchased from Frazier-Davis Construction, the 108-acre plot of land south of Eager Road referred to by Brentwood citizens as "80 Acres." In July 1949, Shelby Construction began work on the enormous and most modern two-story development of its time. At a cost of over $14 million, 1,385 units composed of one, two, and three bedroom garden apartments were built in less than a year. The development, named in honor of John J. Audubon, naturalist and native St. Louisan, named its streets after birds and was often referred to as "birdland."

In 1978 Jefferson Savings and Loan purchased the 108-acre complex to turn 1,385 units into luxury condominiums and townhouses. Construction practices used in 1950 were outdated for the condominiums in the '80s. The buildings were completely gutted and renovated "from scratch." The only resemblance of the new units to the old is the brick outside walls. It took 12 years to complete the renovations and currently a homeowners association maintains the 1,200 unit development, called Brentwood Forest.

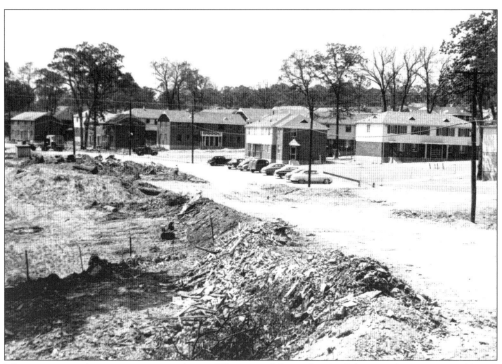

Men prepare a drainage area near future Wrenwood Lane for Audubon Park, *c.* May 1950.

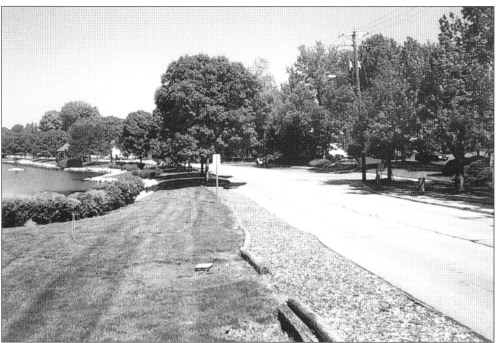

Pictured is a view of Brentwood Forest looking west on Wrenwood Lane. This picture, taken in 2002 from the same location as the above photo, shows that the drainage ditch is now a lake. The homes are no longer visible due to the foliage.

This 1964 aerial view of Bridgeport Avenue shows homes built in the late 1950s.

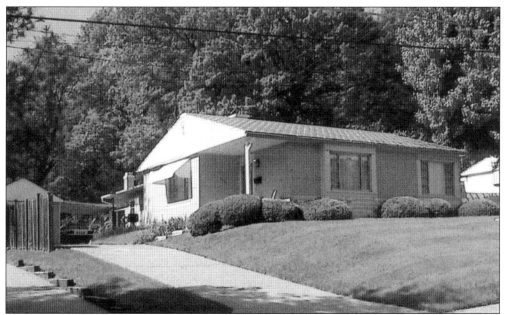

A Lustron home on Litzsinger Road was, like others of its model, 1,000 feet square and constructed of enameled steel with everything built in. The home required little or no maintenance. The company built more than 2,000 homes in the United States between 1948 and 1950. The homes cost between $10,000 and $12,000 when the average cost of a home was only $5,500 to $8,500. Brentwood had 11 Lustron homes built, and most are still occupied.

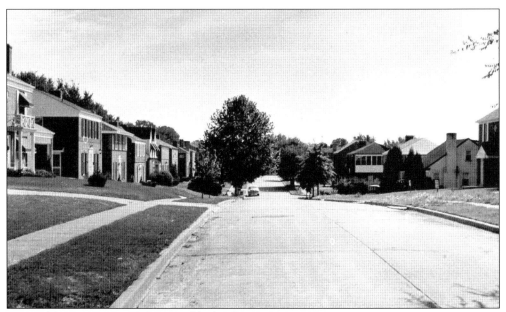

Pictured here is a view of the 9400 block of W. Pine in 1969.

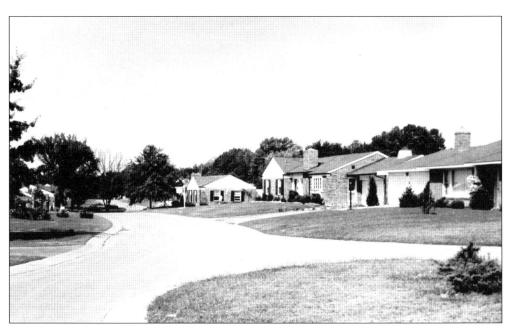

Whitehall Court is pictured here in 1969.

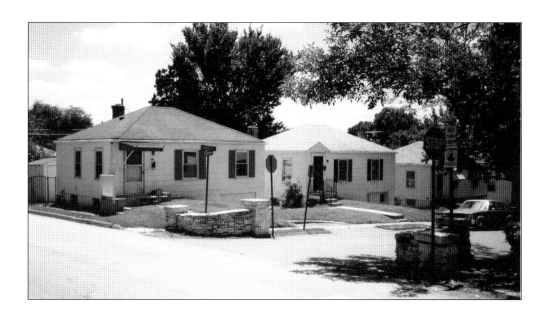

These pictures were taken in 1997 prior to the homes' demolition. They were located in Howard/Evans Place. This neighborhood was populated by the African-American community of Brentwood. They originally moved to Brentwood in the early 1900s to work in the brickyards. The community thrived and had its own elementary school, L'Overature. Once the schools were integrated, the students from Evans Place attended Brentwood Schools.

In 1996 the area was declared "blighted" under Tax Increment Financing (TIF) and the property was sold to a developer to build the Brentwood Promenade Shopping Center. The homes were razed and the community members scattered throughout the St. Louis area.

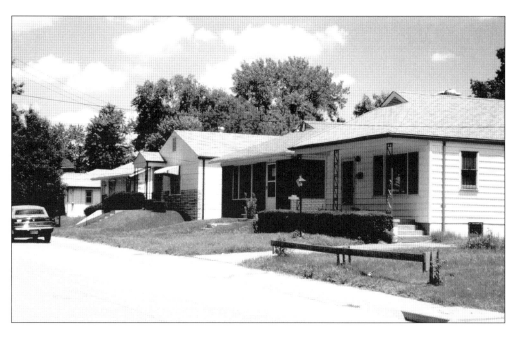

Developed in 1993, the homes on Porter off of Manchester are pictured here in 2002.

This home at 98 Yorkshire Lane, developed in 1996, is one of 19 houses built on property formerly owned by the Brentwood School District. This is the newest housing development in Brentwood.

Two

WHO WE ARE

This chapter represents the people who settled Maddenville and their descendants who developed it into the City of Brentwood. It shows how the organizations and government work together to make it a "City of Warmth." Many people have lived in Brentwood 50 plus years. Those who leave always feel a special attachment to their hometown. In response to Thomas Wolfe's *You Can't go Home Again,* former resident Jerry Marshall says, "Gimme a break, Thomas Wolfe! After all, I grew up in Brentwood. Brentwoodians indeed can go home again. And do." They are always remembered and welcomed.

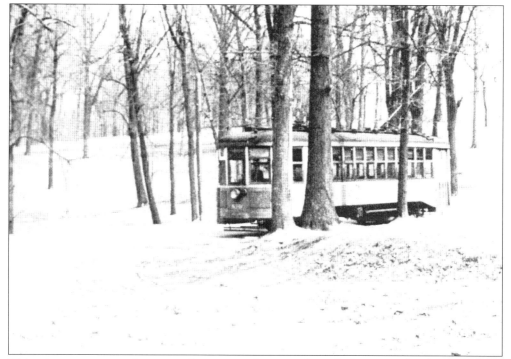

This picture portrays the type of streetcar that ran through Brentwood. The Brentwood "Dinky," as it was fondly called rattled and swayed over its three-mile route from Richmond Heights to Brentwood and back.

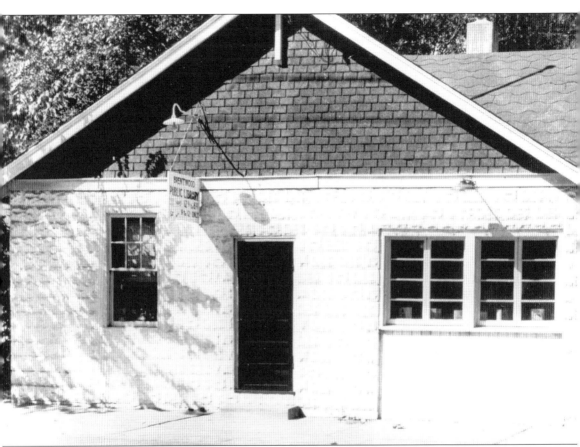

The first city hall, located at 1115 North and South, is pictured here. On March 23, 1938, Mayor Walter Douglas and the Board of Aldermen decided to urge nine citizens to consider organizing a public library. These citizens became the library board and decided to ask for the old city hall building to house the library. Mayor Douglas asked the Works Project Administration (WPA) to provide the labor, and the city provided the materials to recondition the building. The board gave card parties, offered book reviews, and even performed a play to earn money to buy furniture. Local citizens and groups donated books, supplies, and money to get the library started. On September 18, 1938, with 1,100 books on the shelves and $85 in the treasury, the old city hall became the Brentwood Public Library. Miss Lillian Klersch became the volunteer librarian. After the library moved to a new building in 1952, the original building became part of the Brentwood Street Department. The building has been torn down, and Schnucks occupies the property where it once stood.

Louis J. (Pat) Bompart Sr., grandson of the first settler in Brentwood, is pictured third from left with a group of his friends (unidentified) at a Sunday morning dress-up party in early 1900s. Pat attended school through the eighth grade and then worked on the family farm, which was located in the southeast quarter of Brentwood.

A group gathers at Bartold's Grove in the early 1900s. Louis J. (Pat) Bompart sits on the left (others unidentified). Bartold's Grove was a popular saloon and many an old Brentwood resident told how, on a Saturday night, Pat was seen at Bartold's treating everyone who came in. He'd place a hundred dollar bill on the bar and tell the bartender the drinks were on him as long as the money would last.

Florence C. Hill became Mrs. Louis Bompart Sr. when she married "Pat" Bompart, grandson of the first settler in Brentwood. Pat fell in love with her voice one Sunday morning while attending Mass at Holy Redeemer Catholic Church in Webster Groves. Pat and Florence had one son and five daughters and also raised a foster son. Florence passed away August 7, 1940.

Here is the wedding picture of Steve and Pauline Schulte from August 1895. They built a home at 1040 North and South and moved from Oakville to Maddenville in 1906.

Bridgett Hackett, wife of Tom Madden, poses in a portrait taken around 1897. Bridgett was born in 1862 (d.1911) in Kilkenny, Ireland, and came to this area in the early 1870s. Her husband Tom (1842–1916) bought a 100-acre farm from a widow, Mrs. Brazeau.

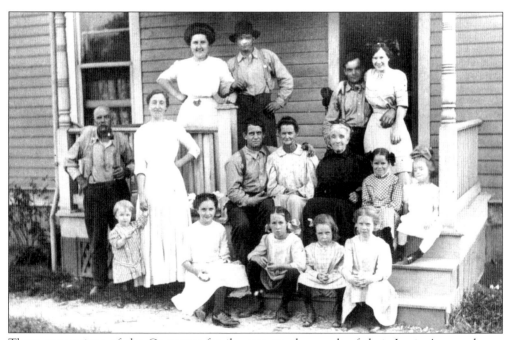

Three generations of the Carpenter family pose on the porch of their Louis Avenue home around 1900.

Mrs. Edna Auer Johnson poses for a picture in the early 1900s.

Louise Litzsinger (1860–1933), a member of a prominent Brentwood family (Litzsinger Road is named for their family), lived with her sister Pauline (Polly) Litzsinger Schulte at 1040 North and South. Louise was blind and taught at the School for the Blind in St. Louis. She was also a published poet.

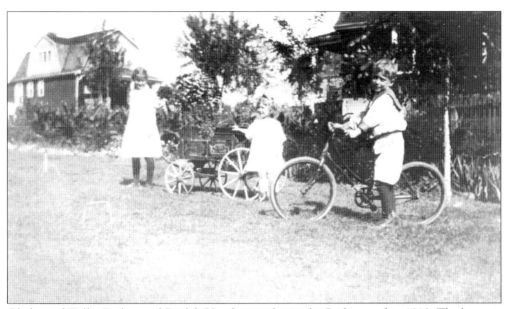

Gladys and Tellie Barlow and Buelah Henderson play in the Barlow yard in 1913. The home is located on the south side of Rosalie. Tellie is very proud of his bicycle, and the girls are playing with their wagon. Notice the croquet set in the foreground.

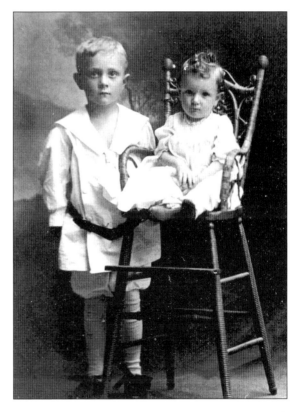

Ewing and Eugene Barlow pose here in 1912.

Anna (Madden) Sadlier and an unidentified young woman stand on the porch of the Patrick Sadlier home, 2800 Brentwood Blvd., in the early 1900s. Anna was born in Maddenville on November 21, 1879. Her father, Thomas Madden, was the businessman of the community. Her mother was Bridgett Hackett Madden.

Pictured from left to right are Roy, Estelle, and Dewey Schulte around 1900. Their family moved to Brentwood in 1906 with the completion of their home at 1040 North and South.

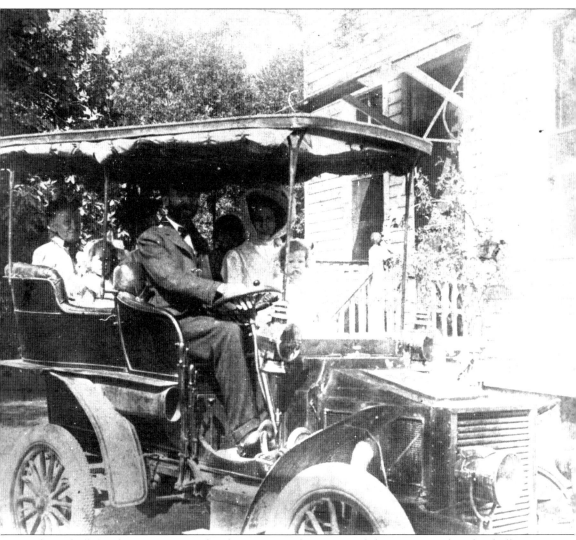

The Schall family is enjoying a family outing in their automobile in 1908. Edward Schall is driving the car while his wife Cora (Meyer) Schall is holding their daughter, Margaret. Margaret later married an Irland. Minnie Schall is seated in the back holding Cora who later married a McGrath (part of the family for whom McGrath Elementary school is named). The Schall's son Charles H., called Mike, is seated next to Minnie. Mike married Anne Mesko. Mike served on the Brentwood Police Department. After his retirement from the department, he served as school crossing guard at High School Drive.

After 1929, police services grew along with the community. To upgrade their training, the men attended various schools and conferences conducted by law enforcement agencies or through University programs. In 1960 the State provided funds for a Basic Police Training School at the Missouri State Highway Patrol Academy in Rolla, Missouri. Two officers of the Brentwood Police Force were members of the first class in September 1960.

Gladys Barlow poses in the backyard of her home at 8754 Rosalie around 1918. Gladys lived in Brentwood for almost 90 years, attended school in Brentwood, and taught first grade at Brentwood No. 1 and McGrath Elementary until she retired in 1975. In the background of this picture is Rock Hill School No. 2 later changed to Brentwood School No. 1. Gladys remembers playing hop scotch with the stone pieces chipped from the sign when workers changed the name.

This picture is of Estelle Schulte Koerber, daughter of Polly, in her graduation dress when she graduated from Rock Hill No. 2 on August 15, 1914. Rock Hill No. 2 became Brentwood No. 1 in 1921.

Pictured is Herb Strassner, a long-time Brentwood resident, who served as city clerk before leaving to serve in World War II. Upon returning he was elected as an alderman. Herb served for 22 years and was Chairman of the Public Works Committee. He was one of the founders of the Brentwood Historical Society. He was still an alderman at the time of his death in 1986. Strassner Avenue is named in his honor.

Mrs. Harriet Bartold Mitchell and Mrs. Arline Bartold Eves walking west on Manchester Road as it appeared in 1917.

The William N. Jones family pictured in front of the family home in the 1920s.

Residents of Brentwood are seen here in 1921 at a picnic in Bartold's Grove located at Manchester and Hanley. Standing at the far left is Myrtle Miller, kneeling in the center is Mrs. Laura E. Schierech, and Helen Lucille Schierech Hauser is the child on the left.

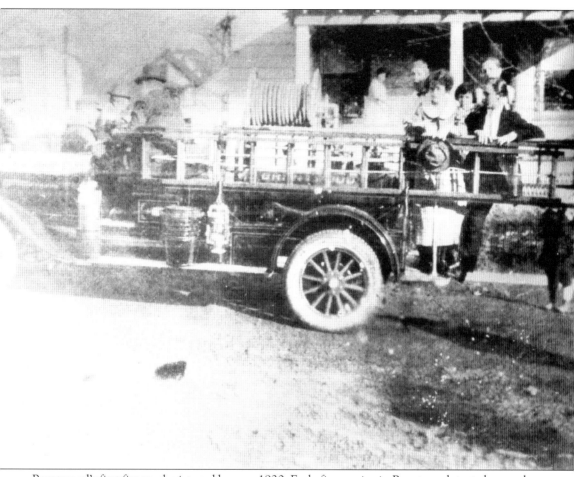

Brentwood's first fire truck pictured here, c. 1920. Early fire service in Brentwood started around 1900, when Paul McCormick, the first acting fire chief, agreed to be a $1 a year volunteer, take calls over his home phone (the city could not afford a telephone), and then reach the other volunteers through a buzzer system connected to their homes.

Until then, neighboring fire departments would respond to a fire only if the caller would guarantee them $50. Citizens were not happy with this system. In 1921 other measures were taken to establish the first local service at 2815 Brentwood Blvd. With passage of a 1934 bond issue, the full-time fire department began in the present city hall in 1935.

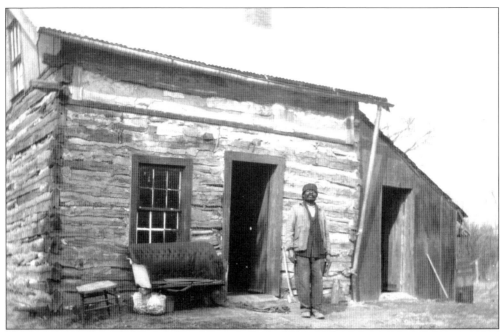

This is Ed Purnell in 1924, standing in front of the log cabin (built by his father, John) where he lived on the southwest corner of Bremerton and Litzsinger. His family was given the land by Mr. Marshall when he freed his slaves following the Civil War.

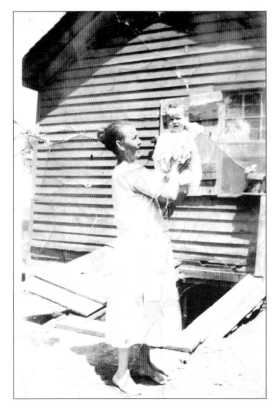

The Richardson home, located on the southwest corner of Bridgeport and North and South, is a typical frame farmhouse, which includes a food cellar. Pictured here in 1925 is Lizzie Thoms Richardson holding her nephew, Louis Gahr.

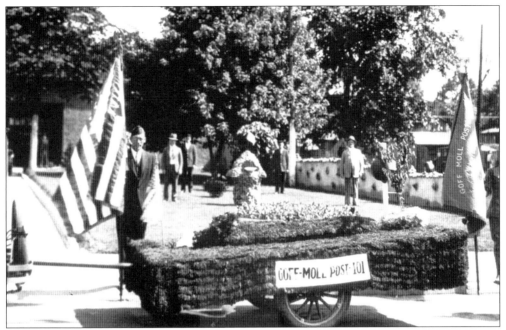

Goff-Moll Post 101, of the American Legion, was organized in June, 1927, through the efforts of R L. Bremner, R.A. Weiland, William McGrath, Carl Bixler, and Robert and Clarence Litzsinger. Thirty-one ex-service men signed the charter, and the first meeting was held at Porta's in Rock Hill. The post was named for two buddies who were killed in World War I.

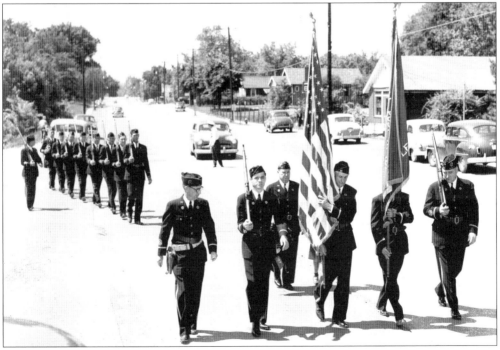

The American Legion Rifle Team at the dedication of the Brentwood War Memorial in 1952 performs the advance and posting of colors.

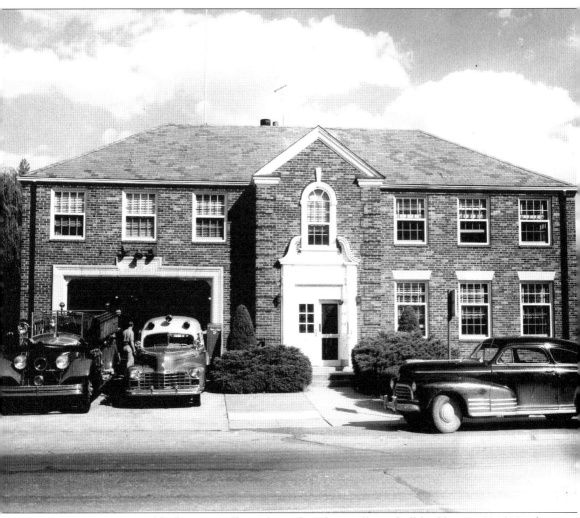

By 1934, Brentwood had grown sufficiently so that the small city hall building at 1115 North and South (now Brentwood Blvd.) was totally inadequate. The City filed for a bond issue, which included the following provisions:

1. For erection of a city hall and fire engine house, purchasing a site therefore and equipment and furniture for city hall, such as desks, chairs, files . . . $30,500
2. For fire apparatus and equipment ... $12,500
3. For Sanitary Trunk Line Sewers ..$63,000

All of the work was to be done through the Public Works Administration. The City assured the citizens that all the laborers would be hired from the Brentwood unemployment rolls first. Pictured is the Brentwood City Hall, built in 1935 after the bond issue passed.

Velma Kephart McManis is pictured here in her backyard at 8630 Joseph, c. 1938. The corner of Florence and Dorothy are shown in the background. This picture was taken to send to her husband, Robert, who was overseas in Europe. She is showing off the dress she made. Velma also served as bookkeeper at the Brentwood City Hall.

Mary McManis is shown here on her front porch on Cecelia Avenue in 1939. Mary was the bookkeeper for the City of Brentwood for many years and moved to Brentwood prior to the town's official designation as a City in 1919.

VOTE FOR

Celeste Rasmussen

Candidate for

B R E N T W O O D
BOARD of EDUCATION

ELECTION: TUESDAY, APRIL 2, 1946

For the Survey For Better Schools

155

Women had always taken an active part in the Brentwood community, though not as elected officials. Celeste Rasmussen was the first woman to run for school board and the first woman to win and serve on the board.

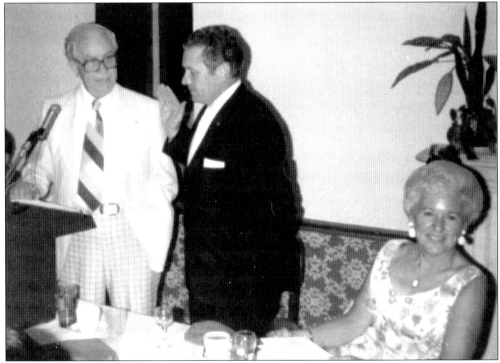

Ray Parker, former mayor and Rotarian, installed Joe Gill as new president of the Brentwood Rotary in 1977. Marie Parker looks on. The Brentwood Rotary was the second oldest service club in the city, having been organized in February of 1948. The first president was Gene Clark. Rotary involves men from a wide variety of businesses and professional fields in service efforts for the community.

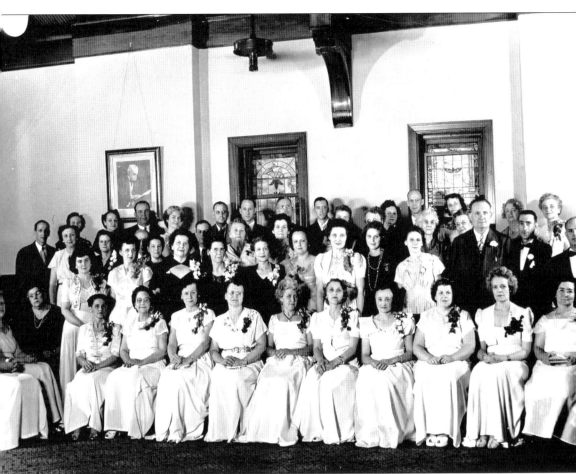

Brentwood Chapter #429, Order of the Eastern Star, was established April 28, 1949, with 53 charter members. Their first meeting was held in the basement of Fairfax House in Rock Hill. The first officers in 1949 are pictured here from left to right, as follows: (front row) Ruth Eves, unidentified, Mary Stimson, Minnie Stahl, Mabel Davis, Flora Ott, Mildred Kurrelmeyer, Maxie McGee, Josephine Conat, Blanch Noecker, Frederica Hall, and Edna Johnson; (second row) unidentified, Peggy Hartman, Edna Smallwood, unidentified, Hazel Elam, Thelma Reed, Mae Billman, Lois Wright, Belle Thomas, Ray Thomas, Claude Noecker, and Ed McGee; (third row) Luella McDaniel, Hazel Grace, Jack Hartman, unidentified, unidentified, Matilda Meyer, Lena Luttrell, unidentified, Mary Summers, Mrs. Rozell, and Nancy Robinson; (back row) Jerry Grace, unidentified, Mary Asselmeier, Edwin Asselmeier, Mildred Pittman, Carl Pittman, John Smallwood, Emmett Conat, William McKenna, unidentified, Clarence Davis, unidentified, Nora Durmant, and unidentified.

Bethel #31 of the International Order of Job's Daughters was established on June 16, 1949, at the Brentwood Congregational Church with 31 charter members. Pictured, from left to right, are the first officers in 1949: (front row) Sue Nichols, Norma Smallwood, Pat Bates, Marilyn Noecker, unidentified, Thelma Manser, Betty Rick, and Sue Weber; (second row) Marian Hounsom, Helen Hounsom, Ruth Hounsom, Fay Bush, Helen Will, Ann Hysmith, Pat Jacobsen, Irma Smallwood, Darlene Brink, and Marylou Wright; (back row) Terry Brink, Mrs. Asselmeier, Rose Rick, Claude Noecker, Marian Poertner, Mary Asselmeier, DeAnn May, Winnie Mastin, Mrs. Poertner, Mildred Kurrelmeyer, and Paul Bragg.

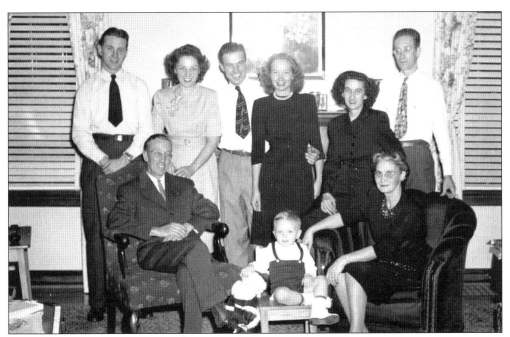

The Kephart family is seated in their living room at 8630 Joseph Avenue. Seated in the picture (c. 1947) are Mirvel and Agnes Kephart and standing, from left to right, are Mirvel Jr. and Frances Kephart, Robert and Velma McManis, and Edith and Emery Kephart.

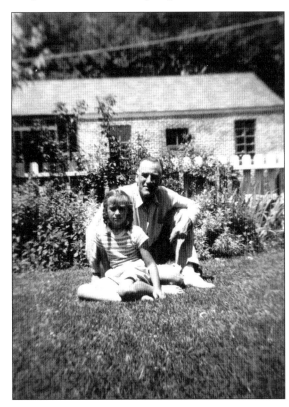

Bonnie Rasmussen and her father, Theodore (Ted) sit in their yard at 2611 Mary in 1942. Ted was a general contractor and the house on Mary was the first of many he built in Brentwood during the 1940s and 1950s.

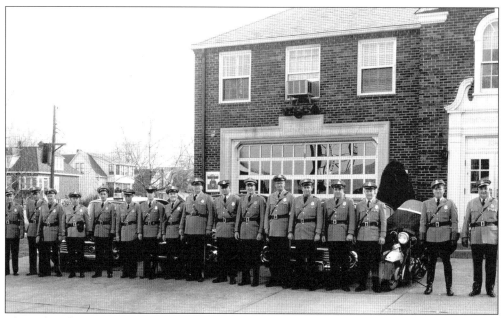

The police department, c. 1950s, poses in full uniform. Chief Fred O. Lain is pictured on the far right. The Brentwood Police Department was the first community in the state to start the DARE (Drug Abuse Resistance Education) Program and the first county unit to have a trained canine on the force (1961–1967) that was trained at the St. Louis Metropolitan Canine School. The current chief of police is William (Bill) Karabas.

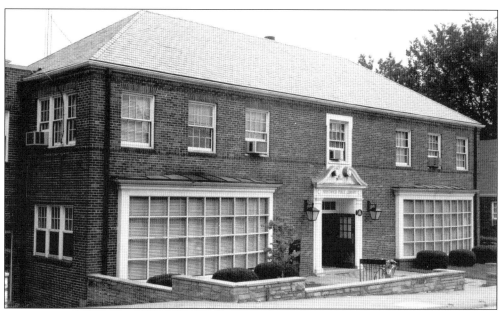

Brentwood Public Library at 8765 Eulalie was opened March 29, 1952, just 14 years after Mayor Walter Douglas appointed the first library board. The building was dedicated by Mayor Ray Parker and other local leaders.

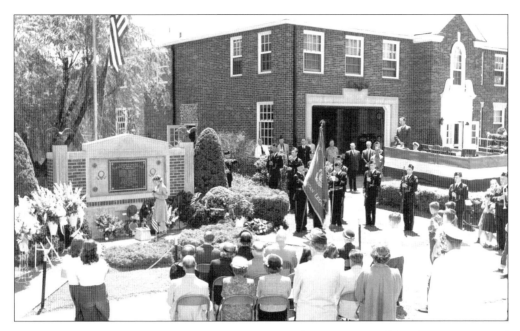

The World War II Memorial was dedicated on October 1, 1944, and listed 538 Brentwood citizens who served. Seven years later, the officers of the Memorial Association decided that the memorial should list in bronze the 15 names of those "who gave their lives in the service of their country" (December 7, 1941, through September 2, 1945) and, in addition, that an Honor Roll Book listing the 637 Brentwood citizens who had served should be presented to the library for display and preservation. Pictured is the dedication of the Honor Roll and the permanent memorial (located on the north side of city hall) held on Memorial Day, May 30, 1952. The Honor Roll Book is at the Brentwood Historical Society. The memorial has since been moved to the south side of the city hall.

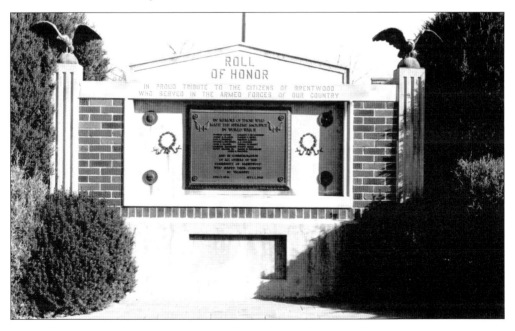

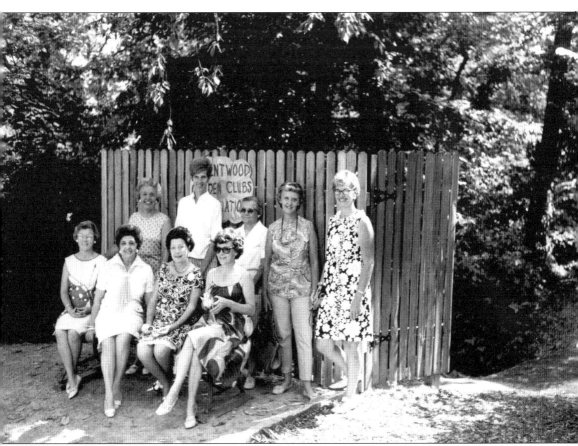

Members of the Brentwood Garden Clubs Association are pictured here in the 1960s. The first garden club was founded in 1941. By 1952, there were eight clubs with 149 members. They were active in all branches of civic life. They donated floral arrangements to civic affairs, helped develop the wildflower trail at Buder tract, planted trees at the High School Drive wedge at Manchester, planted bushes at city hall, and arrangements in planters at the library. Membership declined as more women entered the work place and by 1991, there were only three clubs and the association disbanded. The funds from the association were used to purchase a sundial, which was donated to the City and sat near Walgreens (corner of Litzsinger and Brentwood Blvd.) in the midst of flowers, as a reminder of the garden clubs past and present. The sundial disappeared during the rebuilding of Walgreens and has not been replaced.

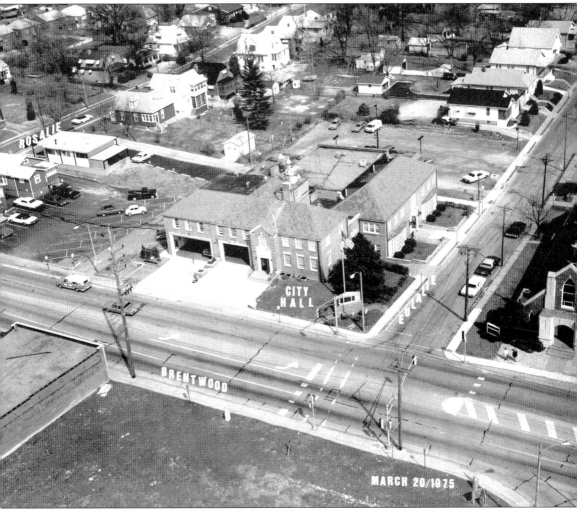

Pictured here is an aerial view of the city hall and library, c. 1975. The city hall building was built in 1935 and the library was added in 1952. Mayors serving Brentwood since its incorporation as a fourth class city in 1929 are as follows: James L. Willingham (1929–1931); Jacob J. Spratt (1931–1933); Walter R. Douglas (1933–1939); Jerome L. Howe Sr. (1939–1941); Charles R. Skow (1941–1943); Oscar A. Tuckett (1943–1951); A. Ray Parker (1951–1963); Edward T. Wright (1963–1976); Arthur J. Oppenheim (1976–1981 and 1983–1987); J. Marvin Shelton (1981–1983); John D. Kelly (1987–June 1988); Karen Kintz (1988–1993); Mark E. Kurtz (1993–2001); and Pat Kelly (2001–present).

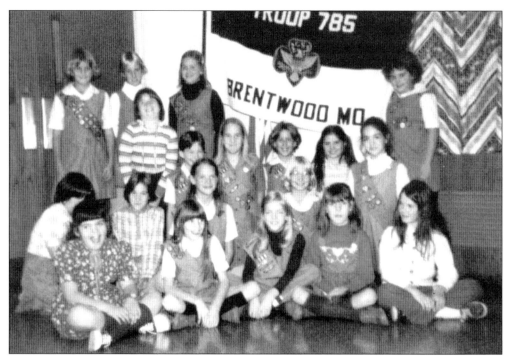

Girl Scout Troops are active in each of the elementary schools including St. Mary Magdalen. Pictured here is Girl Scout Investiture of Troop 765 located at Mark Twain School in October 1979.

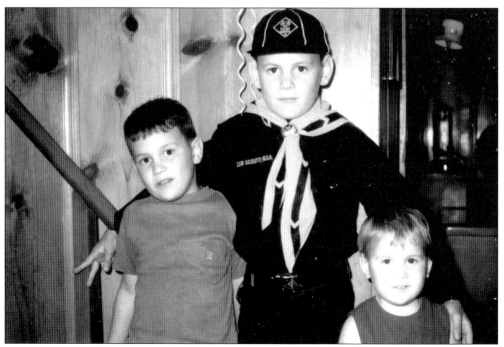

Pictured is Cub Scout Tom Gill with his brother Michael and sister Susie, *c.* late 1960s.

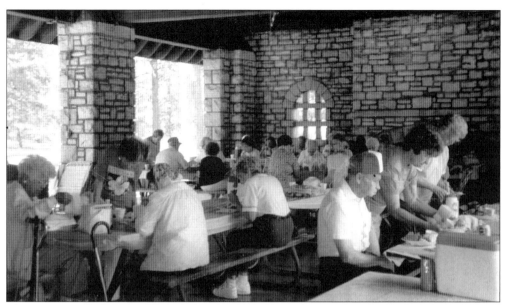

The Brentwood Chapter of the American Association of Retired Persons was established April 2, 1991, under the leadership of Lee Reisenleiter, a Brentwood resident. Pictured here in July 1994, they are enjoying their annual picnic at Tillis Park.

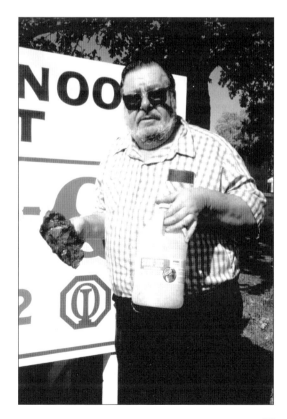

The Brentwood Noon Optimist Club was chartered on January 24, 1968, with Art Oppenheim as charter president. Pictured here is Gene Dodel at one of the Optimist's famous Bar-B-Ques.

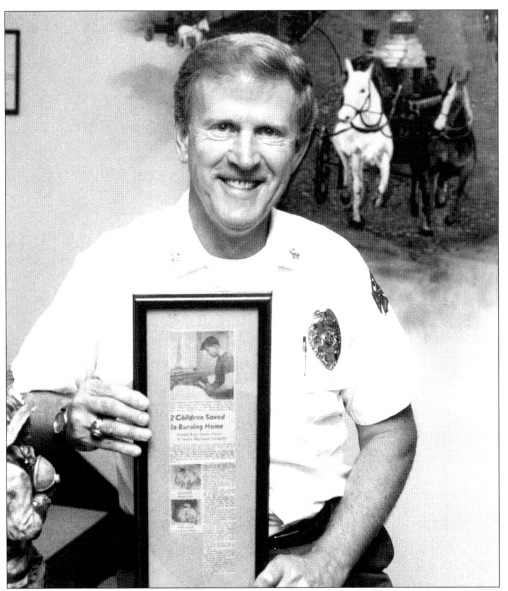

Pictured is Fire Chief Robert "Bob" Neimeyer, the seventh fire chief of the city since it became a village. Paul McCormick served during the volunteer years. George W. Bernard was the first full-time chief and Frank M. "Taft" Moritz followed him. Arthur Noss Sr. served from 1953 to 1965. Robert Watts, 1965–1978, Les Turilli, 1978–1982, and since 1982 Robert has served the town.

Not many people know that Bob Niemeyer started out as a police dispatcher in 1961. He transferred to the Brentwood Fire Department a year later. In 1967 he was awarded fire fighting's highest honor, "The Gold Medal of Valor," for rescuing Jan Miller, the youngest daughter of Dr. and Mrs. Donald Miller from her burning home at 2518 Helen in 1966. He also received the Missouri Fire Rescue Award for bravery and Brentwood's Fire Rescue Award. Bob never brags about his outstanding career, but he has 5 rescues and 26 commendations to his name. He is highly respected by his men and the residents of Brentwood. He has served 40 years in the department, 20 of those years as chief.

Three
FAITH AND CARING

Within the small area of 2 1/2 miles, there are now six churches. Each has an interesting history and gives strong support for all community activities.

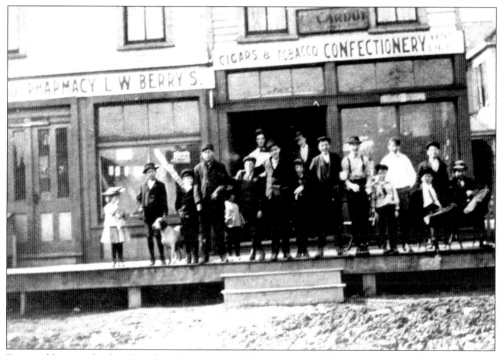

Pictured here is the first Sunday school class of the Brentwood Congregational Church in 1903. Sunday school class met every Sunday and church services were held on every third Sunday. Church has always been important to the community. In the early years, all the activities of the community centered around the churches. Much time and energy were spent raising money to build churches, buy buildings for churches, pay off church mortgages, and increase membership. Religious training and activities for children were a priority. In the 1950s and 60s, the Congregational Church had "Teen Town" and the Catholic Church had "CYC Dances" to keep the youth of Brentwood busy.

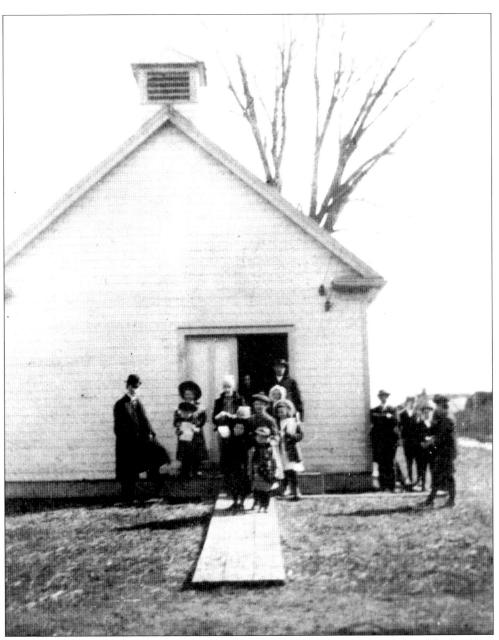

The Brentwood Congregational Church as it appeared in 1910. The church started in 1903 as a home missionary enterprise by the First Congregational Church of Webster Groves. In 1905, property was purchased on North and South Road (Brentwood Blvd.) and Pendleton. The church was dedicated in 1906. The church was growing and a room was added to the chapel and used for the primary grades. Since things were going so well, the idea of having a church bell was brought up. Everyone was in favor and thought it would be wonderful, but the church did not have cash to purchase one. Through efforts of everyone, men, women, and children, enough cash was finally collected and the bell was purchased in 1910. It was placed on the roof of the little chapel. It was used for any emergency in town, often a fire. Although the small chapel was closed due to the 1918 flu epidemic, the bell was saved for future use.

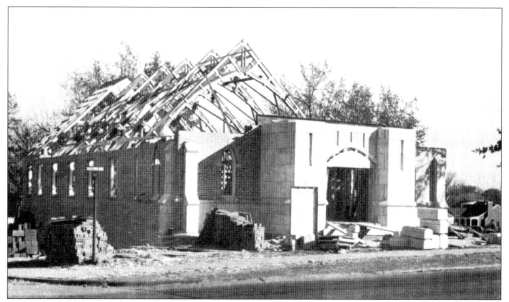

In 1922, the Brentwood Congregational Church was revived by 28 members. Its current location, 2400 Brentwood Blvd. at Eulalie, was purchased in 1924, and a basement church built for worship was completed in 1930. The sanctuary was built in 1940 and dedicated February 2, 1941.

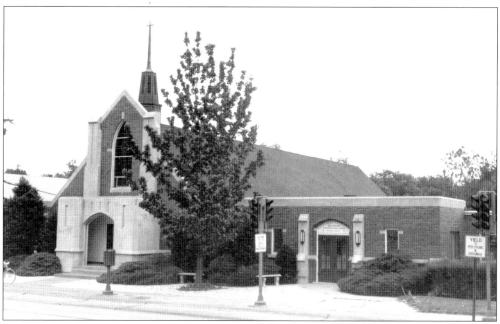

By 1944 the Brentwood Congregational Church had grown sufficiently to cease its missionary status and became entirely self-sustaining. The bell in the belfry was purchased in 1910 and used by the town for emergencies during the early 1900s.

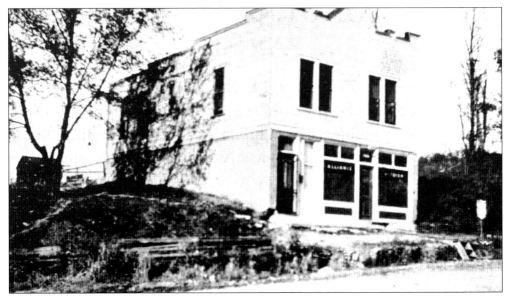

The first Mass of the new St. Mary Magdalen parish was celebrated on March 17, 1912, in a renovated building at the corner of North and South, now Brentwood Blvd. and Russell Avenue. That same year, new lands were acquired just to the north of the parish hall.

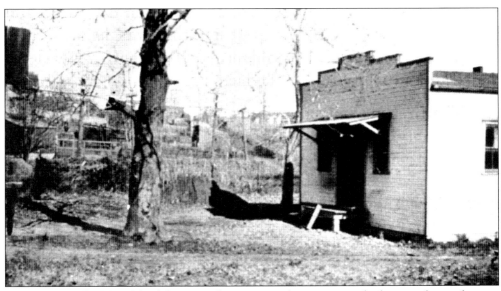

In June, 1913, St. Mary Magdalen moved to its second site, a grain shed across the road.

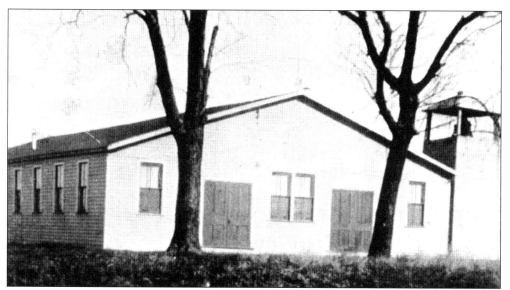

In 1915, the grain shed flooded and St. Mary Magdalen made its third move, this time into the parish hall.

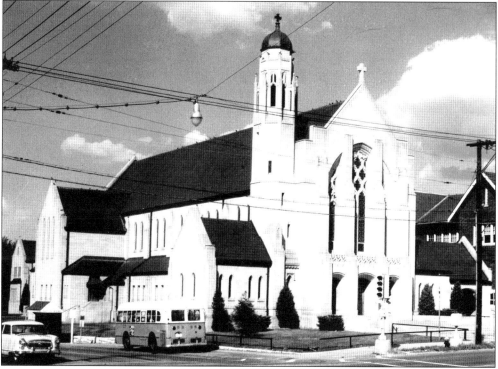

Groundbreaking for a new church and rectory at the corner of Brentwood Blvd. and Manchester Road took place in spring 1942; however, the war caused construction to be indefinitely suspended. Work on the new church was resumed in August 1944. Finally, on May 25, 1947, Archbishop Joseph Ritter presided at the dedication of the present St. Mary Magdalen Church and rectory (cost $280,000).

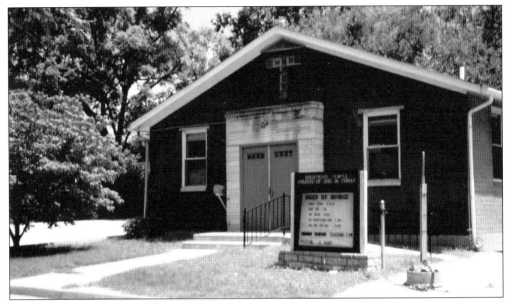

Brentwood Temple Church of God in Christ was located at 1610 Withrow, built in 1955 and remodeled in the early '80s. The church was originally organized in 1926 by Elder Fred Mulligans and met at 8706 Rose Avenue until 1955. When Elder Mulligans died, Elder Grant Price was made pastor and served over 35 years. The church was torn down in 1997 for the Brentwood Promenade Shopping Center.

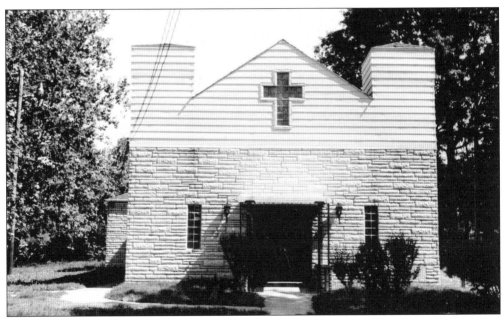

New Hope Missionary Baptist Church was organized in 1932 in a private home in the 8600 block of Grace Avenue. The church pictured was built in 1949. The church was moved when Evans Place was razed for the Brentwood Promenade Shopping Center in 1997.

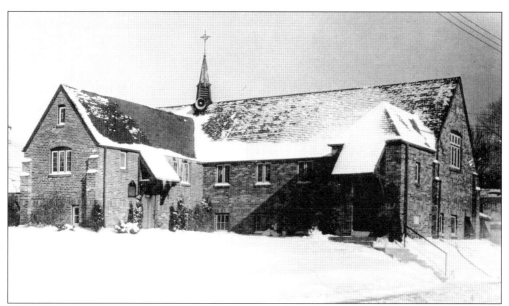

Pictured is Mt. Calvary Lutheran Church, c. 1932, located at Brentwood Blvd. and Rosalie. The church was organized by six people on October 30, 1930, and held its first meetings in a store front at 1729 Brentwood Blvd. In 1951, the congregation purchased 7.8 acres on Litzsinger Road at the west end of the city on which Van Horn's Restaurant had stood from 1918 through the 1940s.

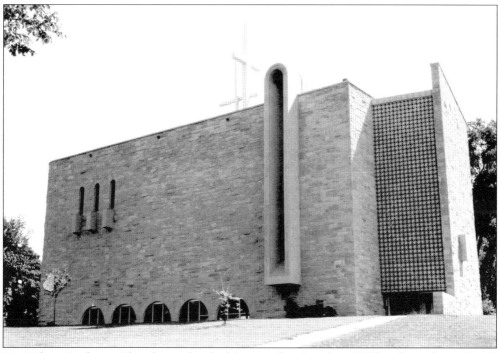

Mt. Calvary Lutheran Church voted to build a new church in June 1963 and tore down the old buildings. The original building, the Stone Castle, was built in 1789, and was one of the oldest landmarks in St. Louis. The new church was dedicated April 4, 1965.

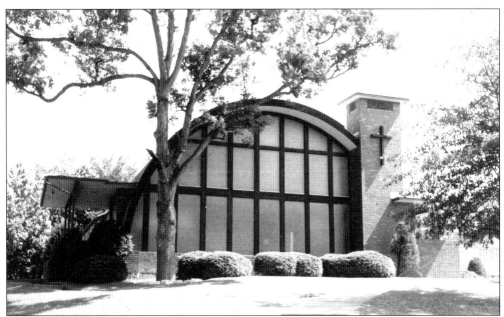

On February 26, 1927, at a prayer meeting held at the home of Mrs. Chloe Wymer and her daughter, Mrs. Pearl Whitaker, the Rock Hill Baptist Church was born. By 1930, a basement church was constructed at Rockford and Golden Gate in Rock Hill. In 1950, the church built and moved into the Quonset building pictured here at Manchester and Bremerton, which was demolished in 1995 when a new sanctuary was built.

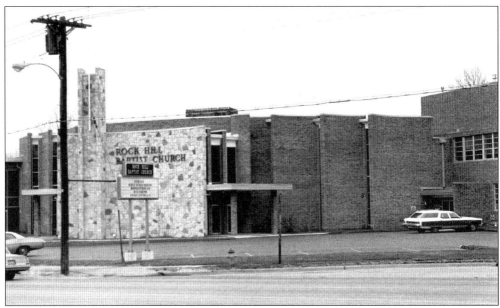

Rock Hill Baptist Church built their educational building in 1955, and in 1962, they added an activities building. In 1978 the church purchased the adjoining properties and built their auditorium, which has a seating capacity of 850 persons.

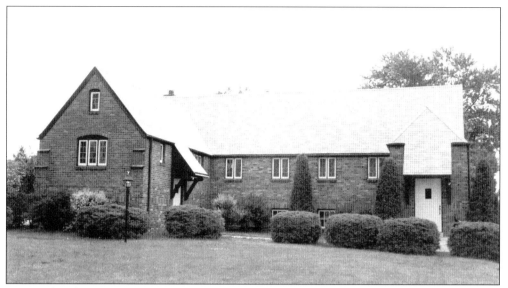

Pictured is the First Church of Christ Scientist Church Building (1952–1973). In November 1943, Christian Scientists who lived in Brentwood began to hold services in area homes. In 1944, they began holding services on Sunday evenings in the Brentwood Congregational Church. In February, 1950, the group, now a "Christian Science Society" moved to the Brentwood Temple. They purchased the church building at 2329 Brentwood Blvd. in January 1952, and finally had a permanent "home".

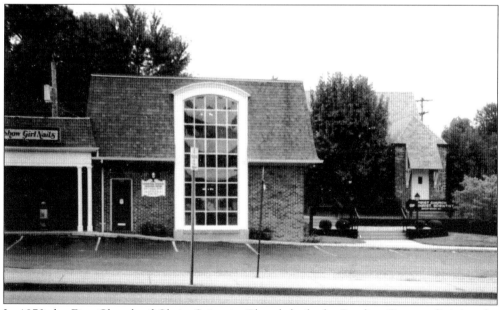

In 1973 the First Church of Christ Scientist Church built the Reading Room, adjoining the church and adjacent to the Brentwood Mall.

Brentwood Bible Church began its ministry in the late summer of 1957. The first few years were spent in rented facilities in old Audubon Park, now Brentwood Forest, and at the Mid-County YMCA. The congregation began holding services in their own building on Lawn Avenue on June 4, 1961.

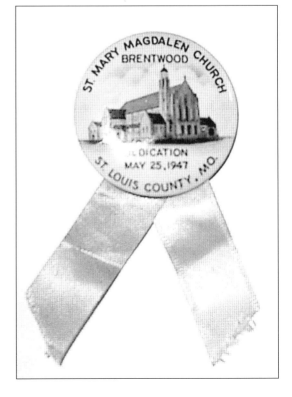

Pins like the one pictured here were given to everyone attending the dedication ceremony on May 25, 1947, for the new St. Mary Magdalen Church. Archbishop Joseph E. Ritter presided at the ceremony. This new church was the fulfillment of a great dream of the second pastor, Father Gerald McMahon, who served the parish from January 1942 to February 1960.

Four

LEARNING AND GROWING

The Brentwood School District is one of the smallest in the area. It was established on March 3, 1920, three months after the village of Maddenville became the town of Brentwood. One of the main reasons for establishing the town was the desire for an independent school. The Catholic school—St. Mary Magdalen—was established in 1922.

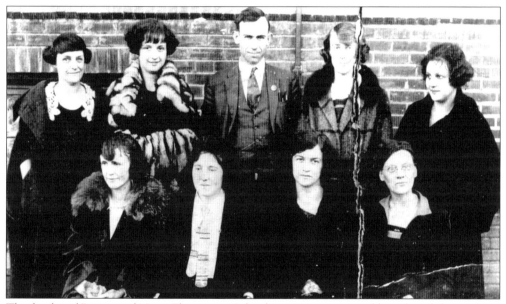

The faculty of Brentwood No. 1 Elementary School in 1924 are pictured here from left to right as follows: (front row) Josephine McGrath, Ellen McCrady, Mrs. Marshall, and Miss Fulhogge; (back row) Bessie Moss, Marie Moritz, Curtis Reeves (Principal), Madge McGrath, and Cara Alt Walter.

Brentwood School District organized in 1920 to provide an education for the community's children that the parents could influence. Prior to this time, the elementary children went to Rock Hill School No. 2 and the secondary school students traveled to Webster Groves or Clayton to complete their education. Once the Brentwood School District was organized, Rock Hill School No. 2 was renamed Brentwood No. 1. The old name was chipped off the building and the new name mounted above the door. As Brentwood continued to grow, more schools were needed. L'Ouverture Elementary was built in 1926; Brentwood High School, 1927; Mark Twain, 1934; and Frazier, 1939. Over the years, Brentwood has continued to value its schools and today the schools enjoy the honor of being "accredited with distinction" by the state of Missouri.

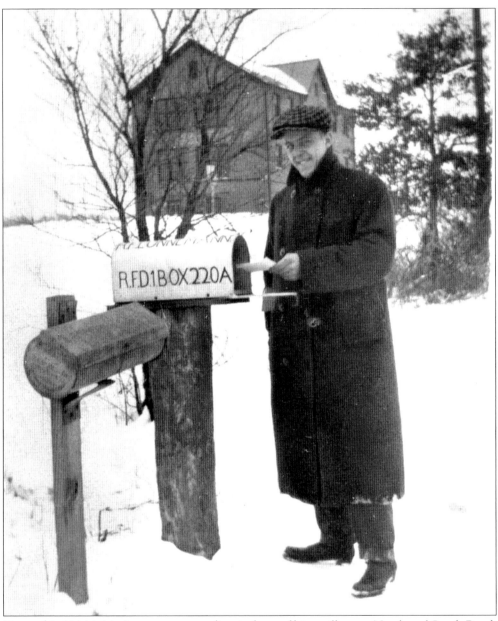

Pictured in 1914 is Mr. Lonnemann standing in front of his mailbox on North and South Road, now 2419 Brentwood Blvd. In the background is the first school in Brentwood, then called Maddenville. The school was built in 1912, on the corner of Warren Avenue (now Litzsinger), and North and South (now Brentwood). It was called Rock Hill School No. 2. In 1920 this building became the first school in the newly established Town School District of Brentwood. It was Brentwood No. 1.

It was originally a four-room building (two rooms upstairs and two down), but as the community grew following two world wars, further additions were made. In 1957, a new modern school at 2350 St. Clair Avenue replaced it. The old Brentwood school building was then sold to an investment company. It was later used as a restaurant, the "Swiss Inn." It was torn down and the space replaced with a Walgreens.

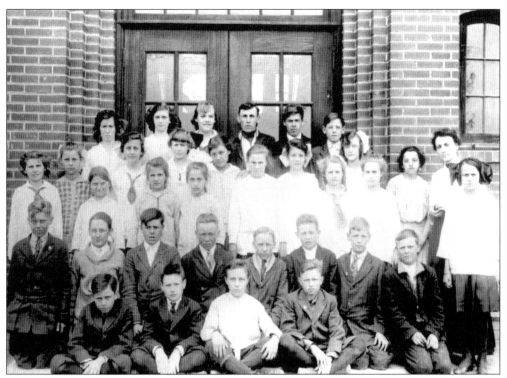

Here is the picture of class 1915 or 1916 at Rock Hill School No. 2, which later became Brentwood School No. 1.

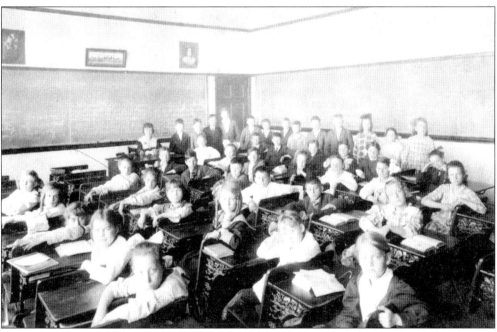

Pictured is classroom No. 3 at Rock Hill School No. 2 on April 4, 1919.

This picture was taken in 1915, on the playground of Rock Hill School No. 2 under the school's "Turn Bar." Pictured is Ruth Tucker Ryan and friends. She lived in Brentwood until her death in 1976.

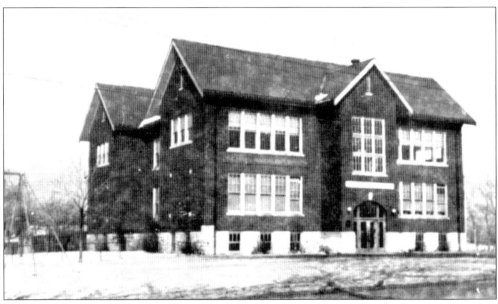

St. Mary Magdalen Catholic Church provides parochial school for students in kindergarten through eighth grade. Their first school building was built in 1922. It had two stories and the second floor was used for parish activities. A new school complete with gymnasium was opened in January 1962.

Brentwood School No. 1 is pictured here in the 1940s. When the school district was established in 1920, there were 408 school age children in a community with a population of 1,395. The community was farmland and children had the opportunity to study nature first hand. The hot lunch program was started by the mothers who took turns preparing hot soup or spaghetti for the children.

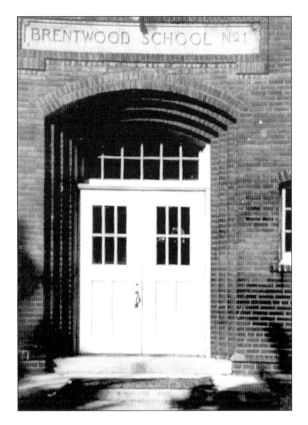

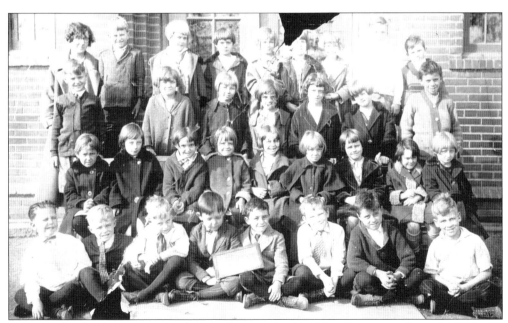

Brentwood School No. 1's second-grade class was lead by Miss Cronan in the early 1920s. Ed Schinke is third from left, front row.

The sixth-grade class at Brentwood School No. 1 in 1924 was led by teacher Miss Madge McGrath.

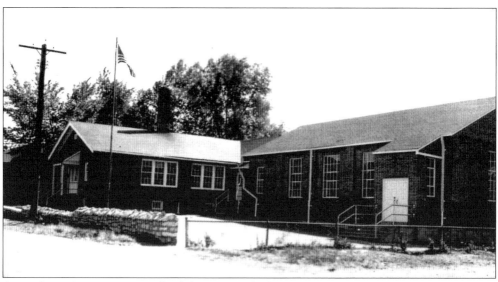

Around 1926, a two-room school house was built on Rose Avenue for African-American students, who had attended school in a church and garage in the neighborhood. The eighth-grade class selected the name for their school, L'Ouverture, after Pierre Dominique Toussaint Breda, a black revolutionist and general who became ruler of Haiti. His nickname, L'Ouverture, means the "opening," because of his ability to break through enemy lines. The school was closed in 1963.

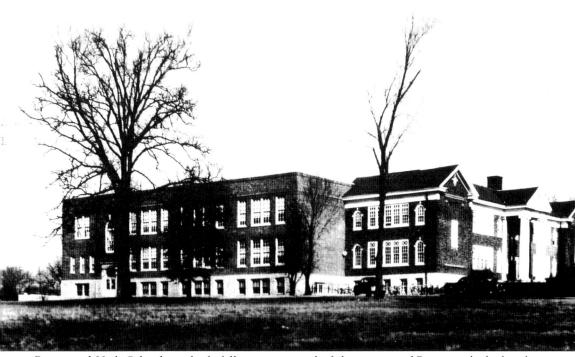

Brentwood High School was built following approval of the citizens of Brentwood of a bond issue for $50,000 on April 5, 1927. The school board voted on April 20, 1927 to purchase approximately 6.4 acres of land from Mr. William L. White (for whom White Avenue was named) for the sum of $6,000 for a new high school site. This is a view of the school in the 1950s with a new building addition. Until the high school was built, eighth-grade students traveled to Clayton for high school training.

During the '70s, the high school structure changed from a school for grades 7 through 12 to two schools: a senior high for grades 9 through 12 and a junior high grades 7 and 8. In the '80s, the junior high consisted of grades 7, 8, and 9 and the senior high 10, 11, and 12. This was again changed when the junior high gave way to middle school for 6, 7, and 8 grades and the senior high reverted to 9 through 12. It remains this way today.

REPORT CARD

St. Louis County, Public Schools

Report of *Lester McManus*

Brentwood C. H. S.

9 Grade _____ Class

	I Qr.	II Qr.	III Qr.	IV Qr.	INDUSTRIAL WORK		I Qr.	II Qr.	III Qr.	IV Qr.
Arithmetic										
Agriculture										
English	90	88	88	90	86 1/4					
U. S. History	82	84			Sweeping					
Language					Dusting					
Physiology					School Lunch-cons					
Civil Gov't			88	90	Bread Baking					
Spelling					Sewing					
Writing					Washing Dishes					
Reading					Ironing					
Geography					Feeding Stock					
Algebra	9?	7?	85	88	Milking					
Gen. Sci.	8?	81	80	8?	Currying Horses					
Deportment	9?	86	86		Providing Fuel					
Tardy	0	0	0		Feeding Poultry					
Days Absent	4?	0	0		Dragging the Road					

TO PARENTS

You will assist the teacher very much by co-operating uring the school year in the following plan:

Under "Industrial Work" please report to the teacher each quarter the progress made by your child at home in the different divisions there outlined, using the letters E, to denote excellent, G, good, M, medium, P, poor, respectively

Lillian Munro

H. C. Peavey Teacher

Pictured is a Brentwood High School report card, c. 1927–1931.

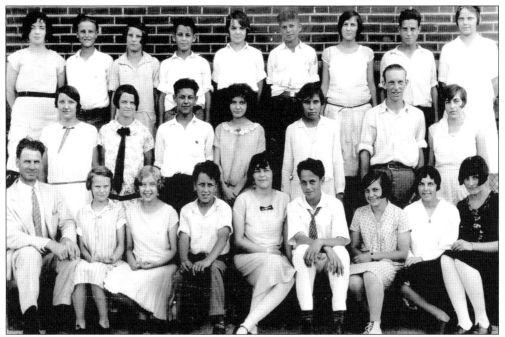

The entire enrollment of Brentwood High School poses in the spring of 1928.

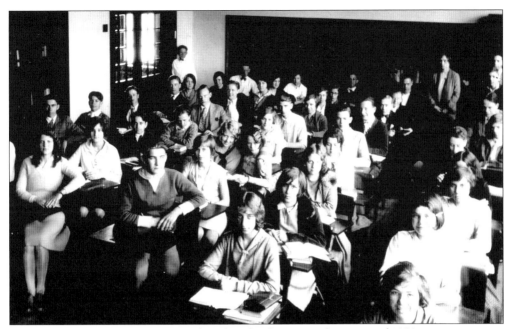

The entire enrollment of Brentwood High School poses in the spring of 1929.

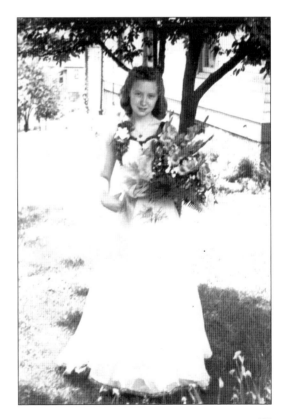

Velma Kephart, shown in her prom dress, holds her graduation bouquet from Brentwood High School graduation in May 1939.

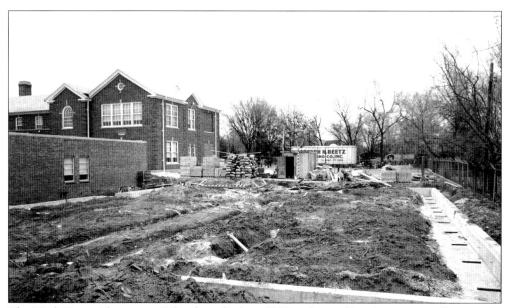

The Mark Twain Elementary School was built in 1934 and served kindergarten, sixth, seventh, and eighth grades with a staff of four teachers and 155 students. An addition was built in 1958 and again in 1969. Pictured here is construction for the 1969 additions.

The construction in 1969 added a new kindergarten and four primary classrooms to Mark Twain Elementary School. This addition allowed for two classrooms on the second floor to be converted to a library.

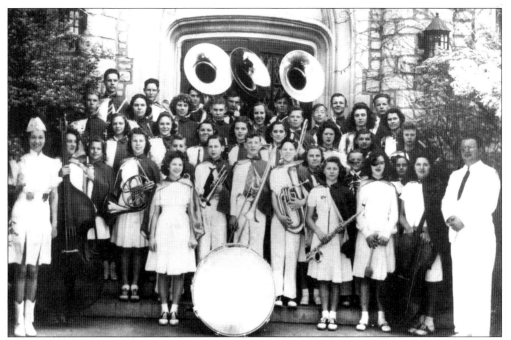

The Brentwood Band, 1941 National First Division winners, led by Howard Vanskike, Music Director.

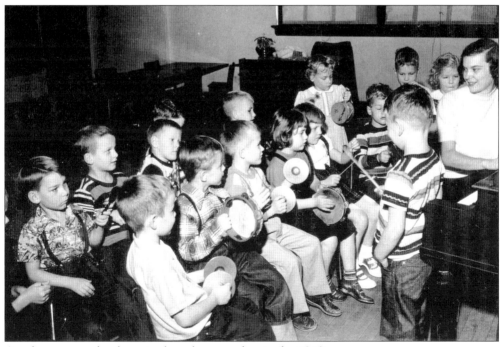

An elementary school music class plays together in the 1940s.

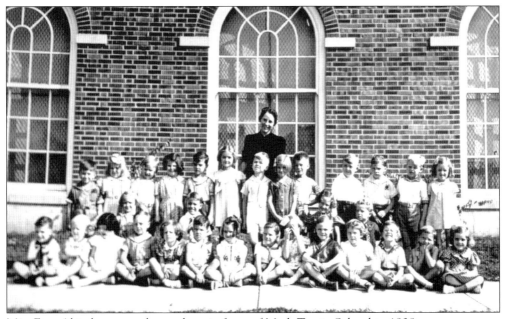
Miss Evans' kindergarten class gathers in front of Mark Twain School in 1938.

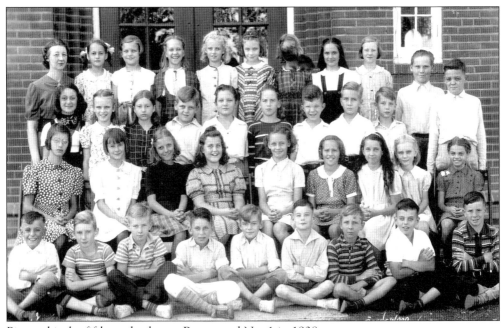
Pictured is the fifth-grade class at Brentwood No. 1 in 1938.

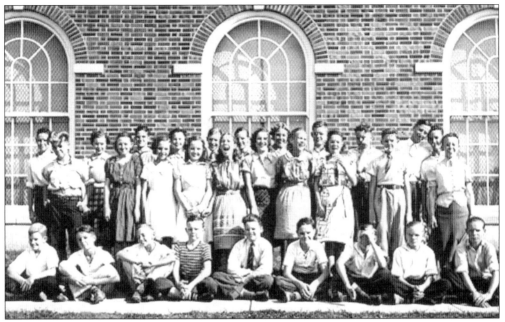

Here is the eighth-grade class from Mark Twain School in 1938.

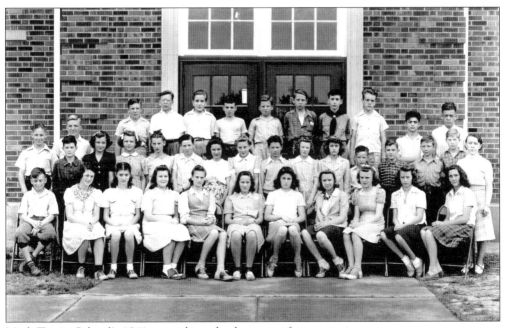

Mark Twain School's 1941 seventh-grade class poses for a portrait.

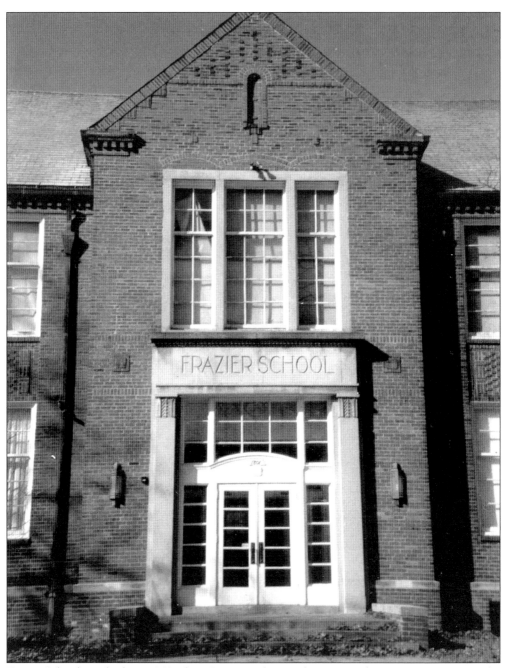

Frazier School was built in 1939 when Brentwood's population was about 4,000. In June 1951, Frazier had an enrollment of 300 students. By fall, the enrollment had doubled due to the completion of apartments in Audubon Park. A bond issue was then passed to double the size of Frazier. This building expansion continued for the next 15 years. When the apartments were changed to condominiums and townhouses, enrollment dropped and Frazier was closed in 1980. The building was rented to Martha Rounds for her childcare academy. She moved her academy to a building on Manchester and vacated the building. The property was sold to a residential developer on April 10, 1995. Homes were built on the property in 1996.

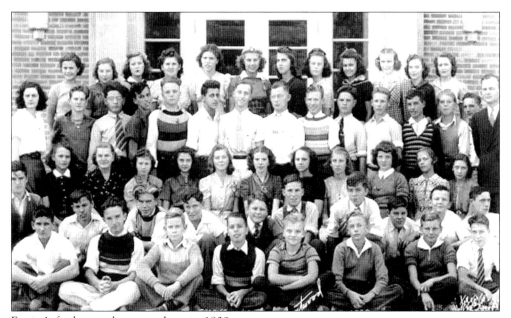

Frazier's freshman class poses here in 1939.

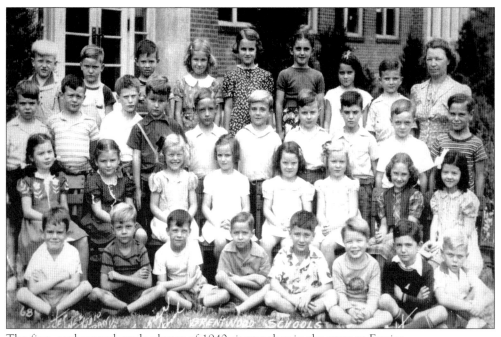

The first- and second-grade classes of 1940 sit together in the grass at Frazier.

The third-grade class from Frazier is pictured here in 1941.

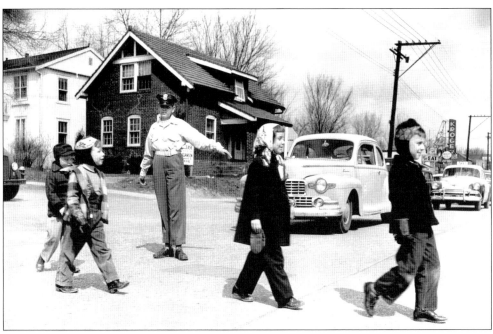

School children cross Brentwood Blvd. at Litzsinger in the 1940s. Note the Kroger Store sign in the background.

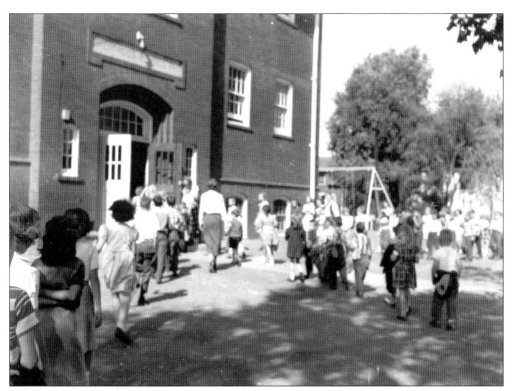

Children return to classes at Brentwood No. 1 following recess in the 1940s.

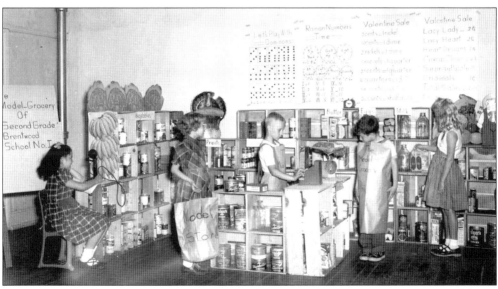

In Mrs. Etherton's second-grade class (c. 1940s), children brought in empty cans and boxes (opened from the bottom) and set up a store. The store experience was used to teach mathematics, customer service, organization, and shopping. The children loved it!

The Brentwood School District Administration Building, located on Litzsinger, is seen here c. 1950.

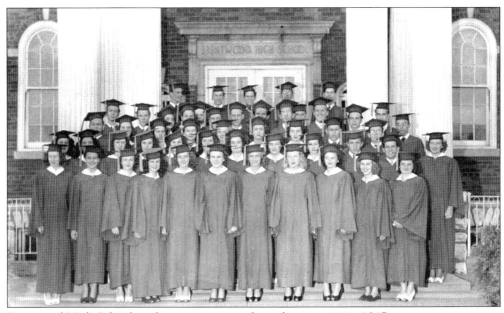

Brentwood High School graduates congregate for a class portrait in 1947.

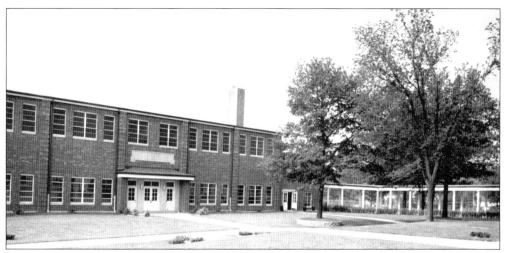

A new gymnasium, auditorium, and cafeteria were added to Brentwood High School in 1954. This addition also moved the Industrial Arts Classes to the new building. A covered walkway was built to connect the buildings. The grassy area between the buildings became a favorite hang-out for the students between classes and at lunch.

In 1957, Brentwood No. 1 was replaced with a new modern school at 2350 St. Clair Avenue. The new school, McGrath Elementary, was named in honor of two sisters who had taught in Brentwood from its beginning. Pictured at the dedication party, from left to right, are Miss Madge McGrath, who started teaching at the Rock Hill No. 2 School; Jerry Howe, former student and Brentwood Realtor; and Miss Josephine McGrath, who had served as both teacher and principal.

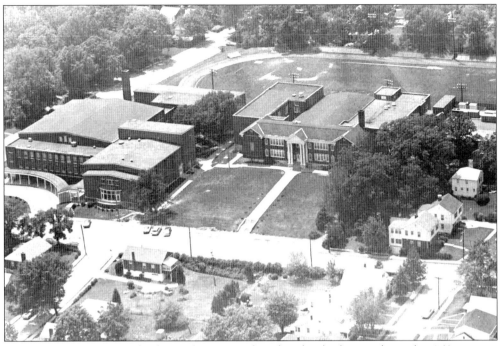

Here is an aerial view of the front of Brentwood High School taken in the early 1960s.

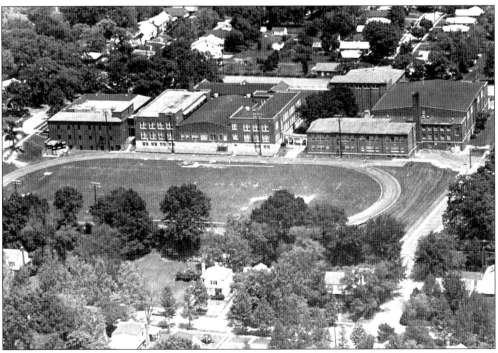

Note the track and football field of the Brentwood High School complex as seen in this aerial view, c. 1960s.

Mark Twain School's 1971 fourth-grade class poses for a picture.

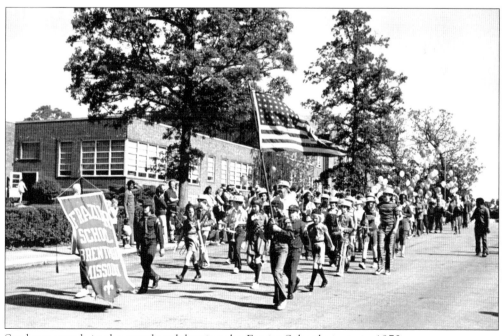

Students march in the parade celebrating the Frazier School picnic in 1972.

The state championship baseball team prepares to depart for the 1978 state playoffs. The players and supporters are pictured from left to right as follows: (front row) Coach Taylor, Michelle Delgado, John Tolish, Rick Newton, Carlos Marconi, Dave Darst, Tim McGrath, and Kevin Zayas: (back row) Mrs. Delgado, Brian Marconi, Laura Pearce, Dawn Martin, Kenny Joyce, Skip Strode, Todd Espey, Terry Delgado, Mike Blaesing, Roger Jones, Amero Ware, Mike Deimeke, Charlie Mayer, Patty O'Rear, and Sandy Tumbas.

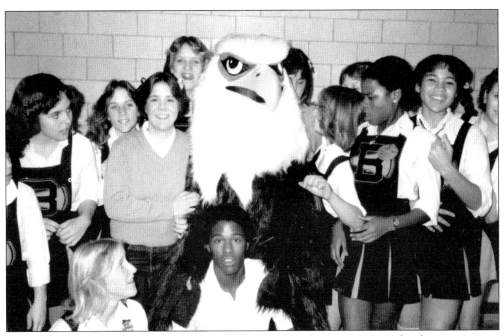

Brentwood cheerleaders and "Beaky," the Brentwood Eagles mascot, pose for their portrait in 1981. Pictured here, from left to right, are the following: (front row) Beth McDonald, Philip Wilson: (back row) Teresa Delgado, Jill Drury, Kathi Cartwright, Deb Shaw, unidentified, Melanie Buerkle, Paula Foreman, Trudy Thompson, and Susie Gill.

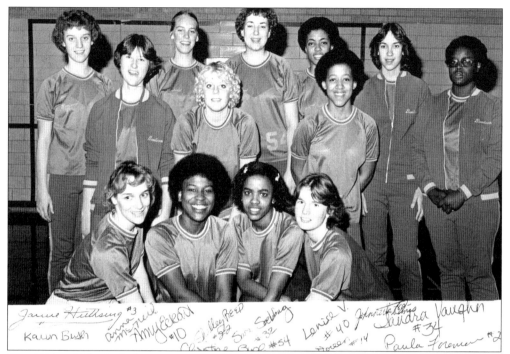

The 1981 girls' basketball team is pictured here, from left to right, as follows: (front row) Janice Huthsing, Paula Foreman, Shelly Reed, and Jill Elias: (middle row) Doreen Jorn, Julie Spree, and Sandra Vaughn: (back row) Amy Eckert, Sara Soebbing, Christine Bush, Lenice Vaughn, Karen Bush, and Anna McNeil.

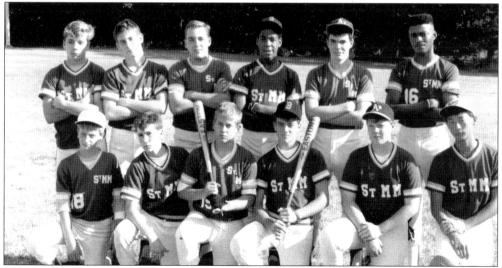

St. Mary Magdalen's eighth-grade baseball team gathers for a picture, c. 1987.

A 1960s Brentwood High Eagles football team takes a rest.

Brentwood High Eagles football teams from the 1960s.

1965 - First undefeated and untied football season, 9-0-0.

1966 - Second undefeated and untied football season, 8-0-0.

1967 - Third undefeated and untied football season, 9-0-0.

In 1967 at a meeting in Kansas City sportswriters voted Brentwood High School the champion of Class M football for the whole state. Chuck Roper, quarterback, and Kurt Gebbhard, tackle, were listed as All-State players, and Chuck was named to a All-America squad. . . both later being recruited by the University of Missouri.

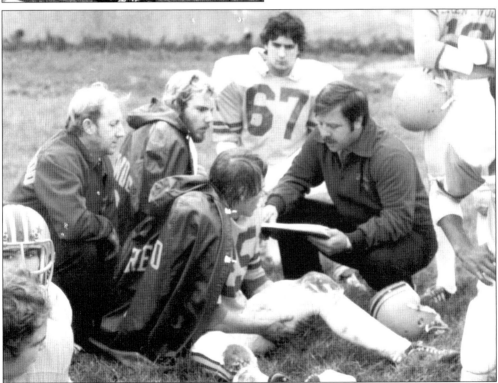

The Brentwood High Eagles devise a team strategy in 1978.

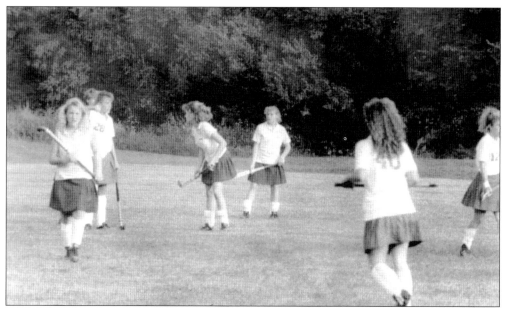

Members of the girls' field hockey team find their positions on the field.

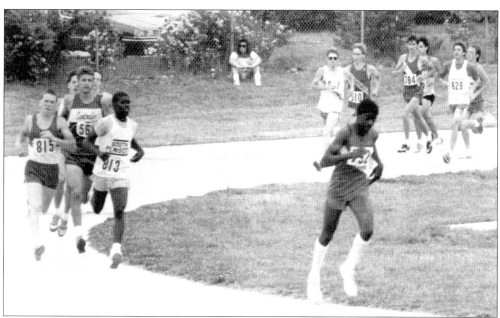

Brentwood athletes compete at a track competition.

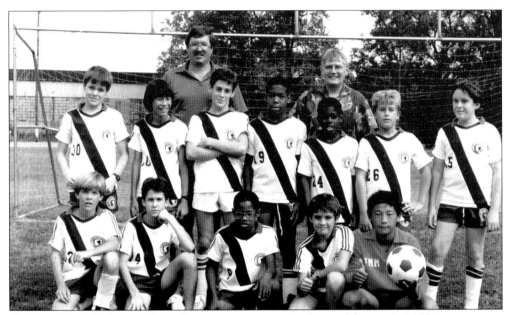

St. Mary Magdalen's seventh-grade soccer team poses in front of the net in 1987.

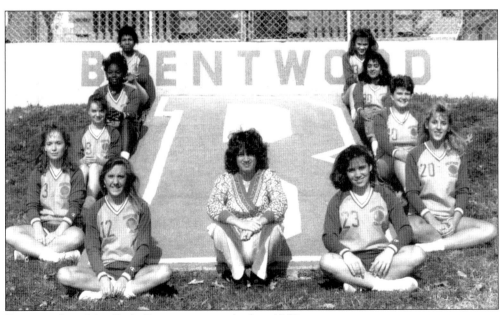

Brentwood's girls' volleyball team poses in the late 1980s.

Five
OUR BUSINESS COMMUNITY

In the beginning, there were small businesses that mainly served the citizens of Brentwood. The businesses grew as the town grew. Larger establishments were encouraged to move into the city. Today, as was true in the past, businesses feel a pride in their contribution to the community. The citizens welcome them for the tax base that supports all the amenities that make Brentwood a great place to live.

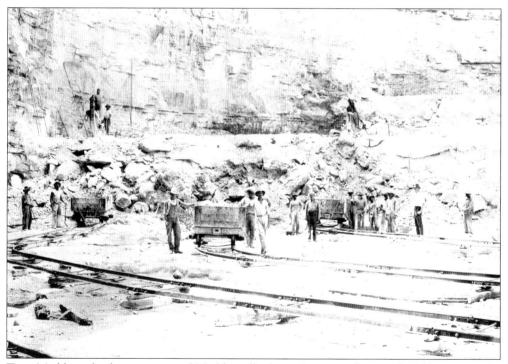

Tom Madden, the businessman of Maddenville (now Brentwood) owned and/or operated a tavern, barber shop, blacksmith shop, grocery store, and quarry. The quarry was located on Manchester just east of Brentwood Blvd. He built many of the roads in Maddenville and the surrounding communities and as well as sold rock and gravel. This view shows workers in 1922. Mexican laborers employed here lived in shacks overlooking the west rim of the quarry. The quarry property was eventually sold to Henry Willming and used as a dump for many years. It is now filled in and a retail store is on the site.

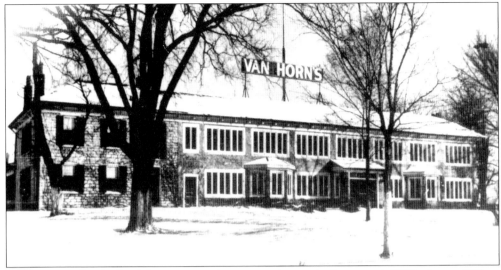

Van Horn's "Rock Castle" was, according to tradition, built around 1789. James Wilgus purchased the property, located on Litzsinger, east of Lay Road (now McKnight Road), in 1836 and his daughter Eliza Wilgus inherited it. She married John F. Lay, a member of a wealthy old Missouri family and real estate operator in St. Louis. Lay Road near the home was named for him. A second floor was added in 1865; porches were built half around the house and numerous out buildings were added.

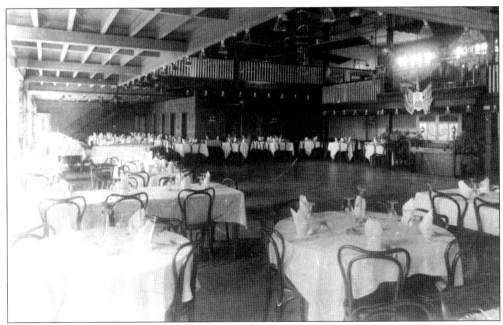

Charles G. Van Horn, one of St. Louis' most prominent restaurateurs, purchased the Rock Castle in 1918. Van Horn's Restaurant was one of St. Louis' finest restaurants until the 1940s. The dining room seated 1000 persons. Mt. Calvary Lutheran Church now occupies the property and the Rock Castle has been torn down.

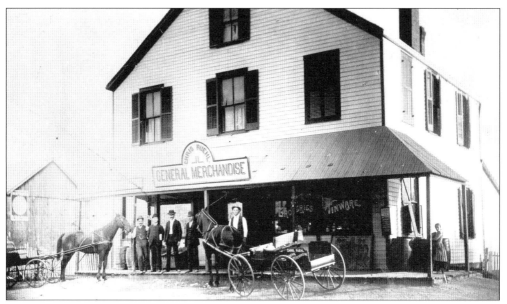

The Kahn Building in the early 1890s housed Chris Ruehl's general store located at Anna and Brentwood Blvd. before being moved around the southeast corner of Brentwood and Manchester.

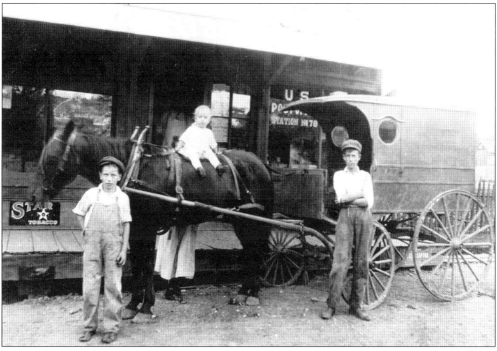

Lester Klersch (left) and Mildred Klersch (held on horse by her mother, Dollie) stand in front of their newly purchased store located at Pendleton and North and South (now Brentwood Blvd.) around 1909. The father, Joseph J. Klersch (standing in the doorway), also handled mail service through sub-station 78 (printed on window). The unidentified boy (right) could be the son of the previous owners, Parks or Whitehall.

Maddenville's "Sanitary Barber Shop," located on the east side of North and South, north of Russell Avenue, was opened by Otto Litzsinger in 1901. A hair cut was "two-bits" and a shave was a dime. Pictured in 1912 is Lillian Holland (center), Orville Litzsinger (right), and an unidentified neighbor girl. Litzsinger Road was named for Philip, Charles, Adolph, Fred, Edward, and Henry Litzsinger, all brothers who settled in Maddenville before 1860. Otto was Philip's son.

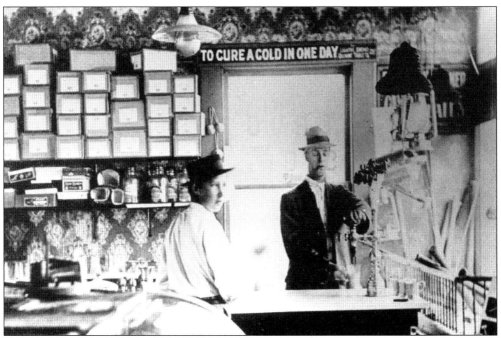

Dr. Eckler's Drug Store was located at Pendleton and Brentwood Blvd.

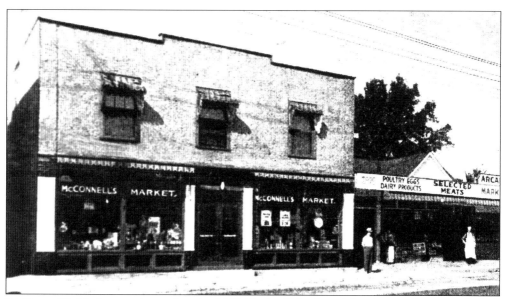

McConnell's Market was located in the 2800 block of North and South, now Brentwood Blvd.

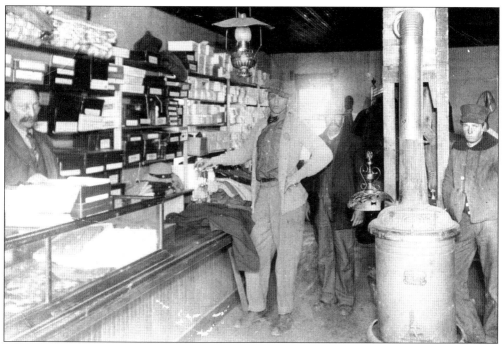

Mr. McConnell stands behind the counter at McConnell's Market. The gentlemen in the foreground are unidentified.

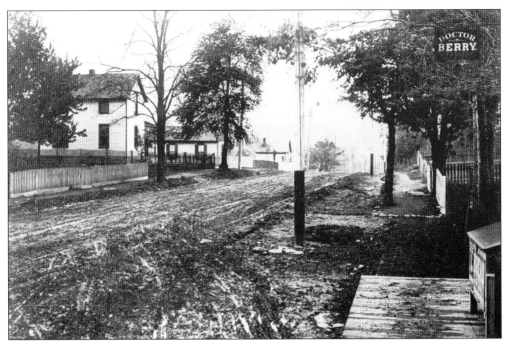

North and South, now Brentwood Blvd. south of Manchester (*c.* 1915), was the heart of Maddenville. Dr. Berry's home and office was across the street from the Schulte home and the Leight house. Down the hill was Russell Avenue.

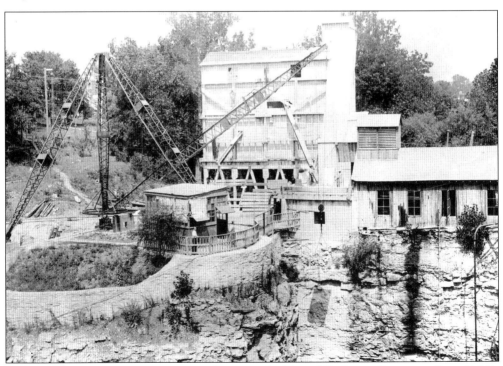

Tom Madden's quarry operation was taken over by United Railways Company (later Public Service Company) in 1914, and provided ballast for streetcar roadbeds throughout the county.

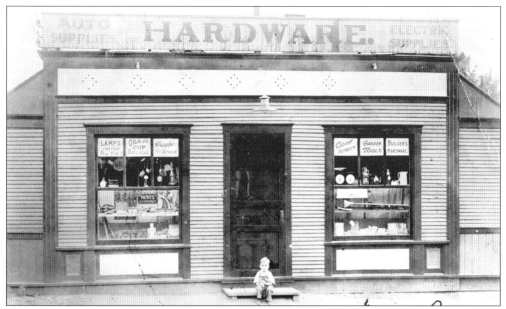

Jim Kalb and friend "Ted Bear," sit in front of his dad's hardware store in 1923. The store was located at 8814 Manchester Road and opened in 1919. It sold hardware, electrical, paint, glass, and more. The store's motto was "what you want when you need it."

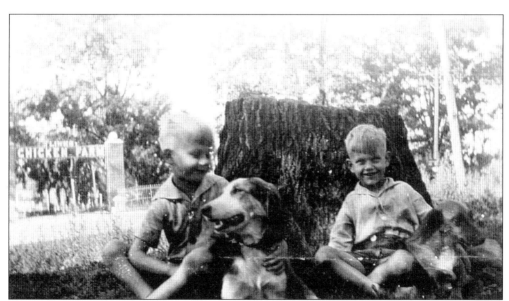

Pictured is the entrance to Links Chicken Farm, c. 1924, on the south side of the 9000 block of Manchester. Gossip claims the chicken farm was really a "road house." Pictured from left to right are Edward Schinke, dog Spot, and Bob Schinke.

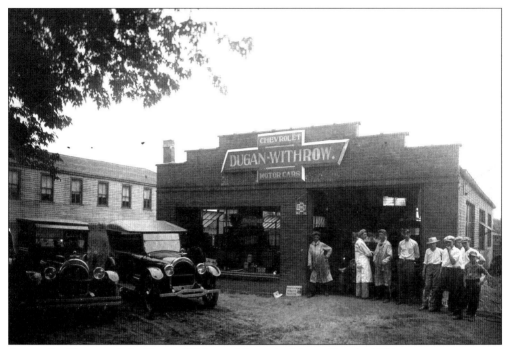

A crowd mills around the Dugan-Withrow Chevrolet Motor Cars in 1924.

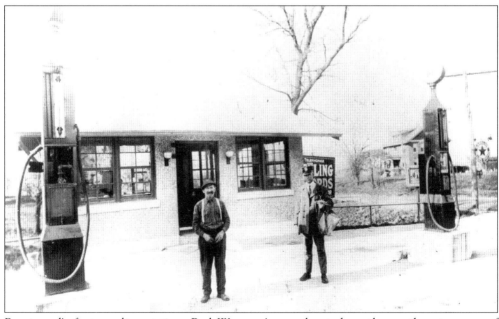

Brentwood's first gasoline station, Bud Weneger's, was located on the northwest corner of Brentwood Blvd. and Manchester; the attendant pictured is John Binder. The mailman may be Frank Dunham.

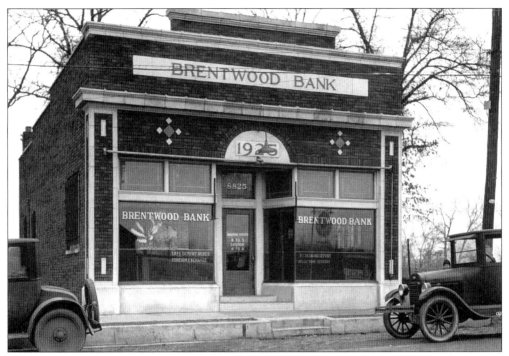

The Brentwood Bank as it appeared in 1925 at 8825 Manchester. This building was later used for Hounsom's Pharmacy.

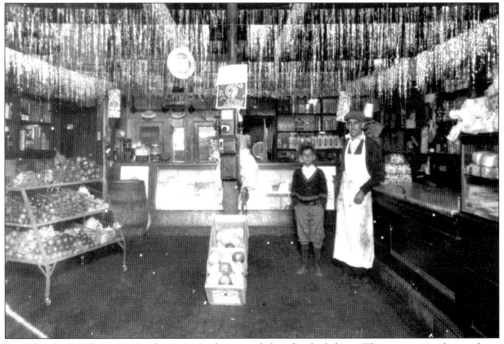

Gualdoni's Foods in December 1926, decorated for the holidays. The store was located on Brentwood Blvd. near Evans (across from Brentwood Square). Pictured is John Gualdoni, the owner, and an unidentified boy.

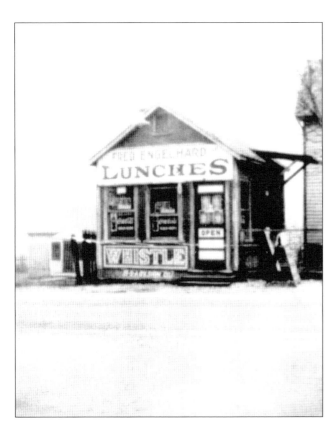

Engelhard's opened in the 1920s and was one of the businesses on Manchester when the original Route 66 passed by. This picture was taken in 1927.

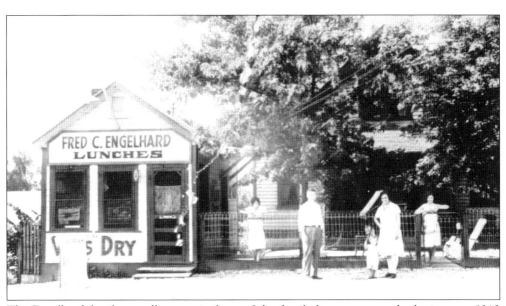

The Engelhard family proudly poses in front of the family home next to the business at 8212 Manchester.

The Engelhard family home has now become a part of the restaurant as evidenced by this holiday card from 1937.

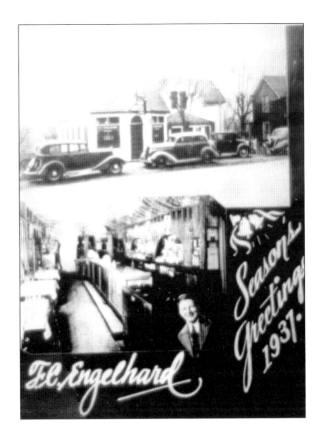

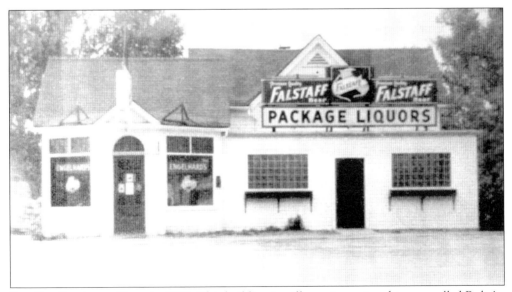

Engelhard's, pictured here in 1955. This building is still a restaurant and tavern called Ruby's.

Bridgeport Confectionery, *c.* 1930s, owned by Mr. and Mrs. Beekman, was the first building on Bridgeport across from Brentwood High School.

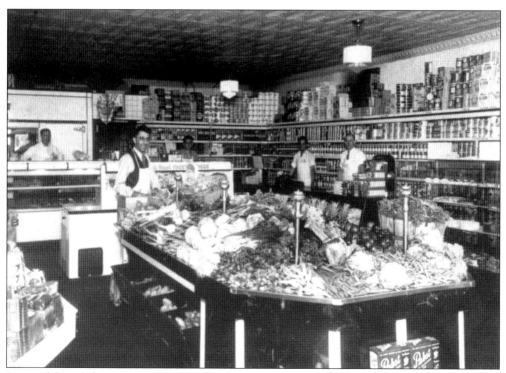

Pictured from left to right at Gualdoni's Foods (located at 2241 Brentwood Blvd.) in 1938 are Lou Brussati, John Gualdoni, Neil Gallagher, Bob Borla, and Louis DeGasperi.

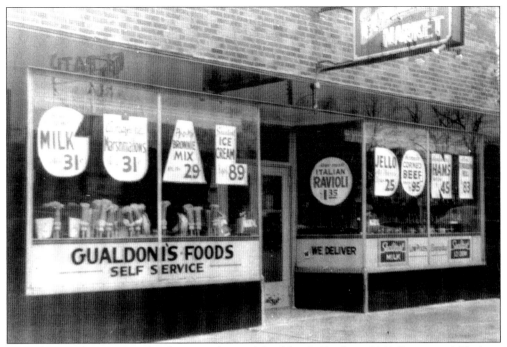

Specials are advertised in the front windows of Gualdoni's Foods at 2241 Brentwood Blvd. in the 1940s. This building is now Frank Papa's Restaurant.

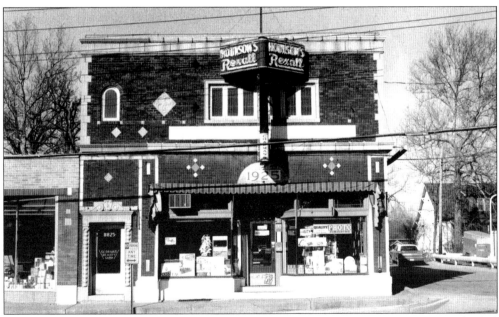

Hounsom's Rexall Pharmacy, located at 8825 Manchester, was owned by Hobart (Mike) Hounsom and his wife, Marie. It had a soda fountain and was a second home to teenagers and retirees. Photo c. 1940s.

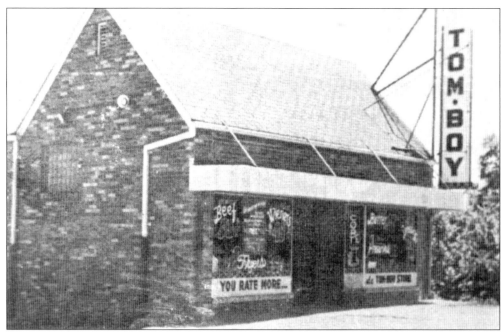

The Tom Boy Store located at 2428 Brentwood Blvd. (Litzsinger and Brentwood Blvd.) opened in 1944. It was called B & B Market. The building is now occupied by Hunan Wok Restaurant.

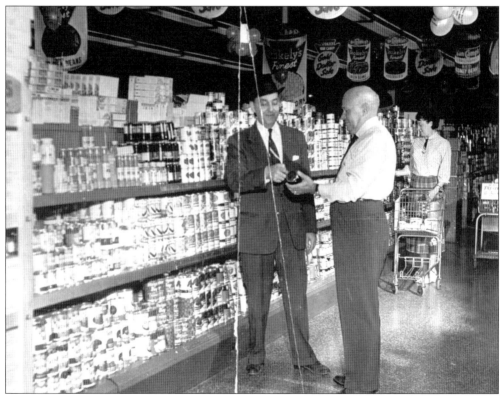

The inside of the IGA Market, located at 2428 Brentwood Blvd., is seen here c. 1946.

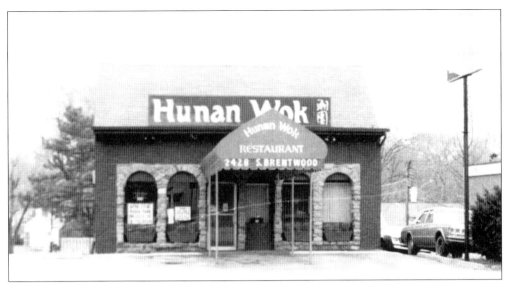

Hunan Wok Restaurant located 2428 Brentwood Blvd.

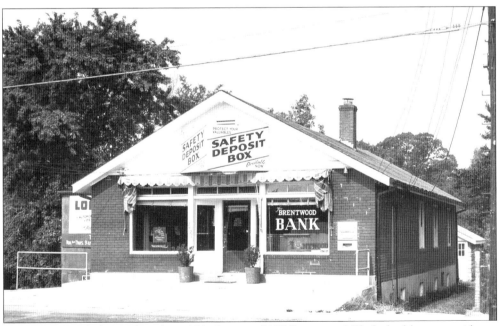

Brentwood Bank, located in this 1953 photo at 2427 Brentwood Blvd., had been a residence converted for bank use. The bank moved in 1957, and this building was occupied by Roth Floral and then D & K Hockey. The building was torn down and replaced by a TGI Friday's in 2000.

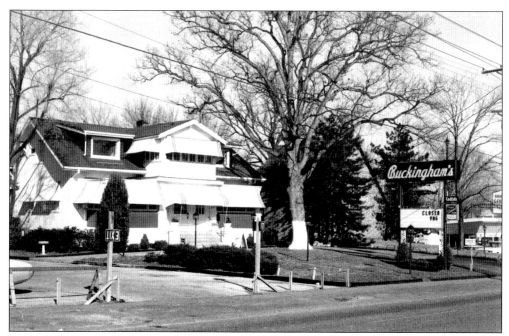

Buckingham's Restaurant, located in the 8900 block of Manchester, was known for its fried chicken.

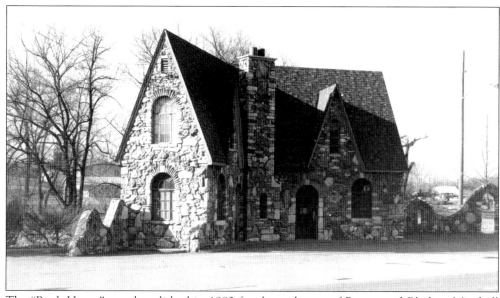

The "Rock House" was demolished in 1982 for the widening of Brentwood Blvd. at Marshall Avenue.

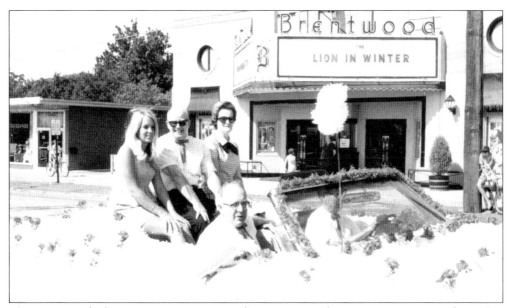

The Brentwood Theater was a mainstay in the community for many years. During the 1950s, shows changed on Sundays; Saturday matinees were enjoyed by most of the children in Brentwood. Admission was 10¢.

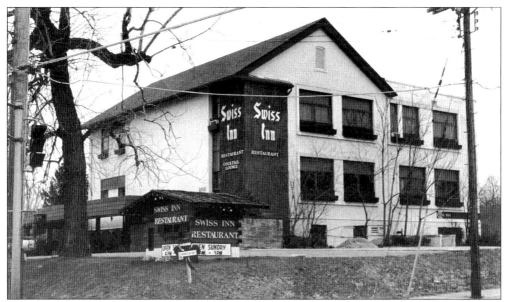

Brentwood No. I School was closed when McGrath Elementary was opened. The building housed several businesses over the years. The Swiss Inn was one of them. The building was torn down in 1987. Walgreens now occupies the property.

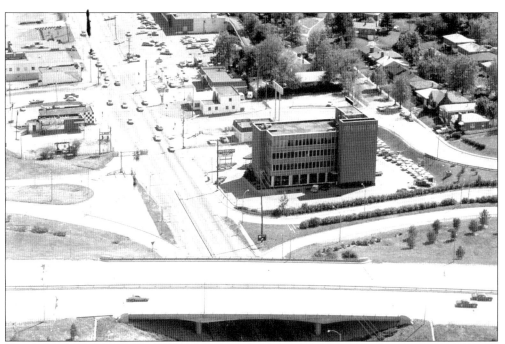

Brentwood Bank, pictured in May 1974, moved to the intersection of Brentwood Blvd. and Highway 40 in November 1957.

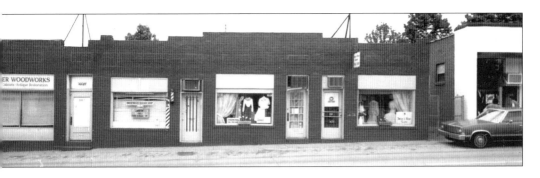

This view of the stores in the 2300 block of Brentwood Blvd. reflects the "heart" of Brentwood from the 1940s to 1970s. The stores changed hands many times. However, the block between Harrison and White contained the "Mom and Pop" stores necessary to sustain quality of life in a small community. In 1986 this block was torn down. It shows the west side of Brentwood Boulevard. Some of the stores remembered are the Hobby Shop, Velvet Freeze, Oxies, Bill's Barber Shop, and Rafferty's Card Shop. Before St. Louis County widened the street, customers of these stores were able to park on the street in front of the store.

The original Lonnemann home became Sugar Creek Gardens in 1991. TGI Friday's now occupies the property.

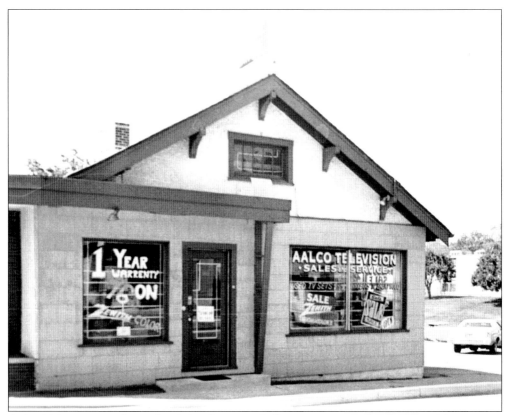

Aalco Television was located on Manchester at Collier. It was owned and operated by Herman Schultz. These buildings were torn down in the late 1980s.

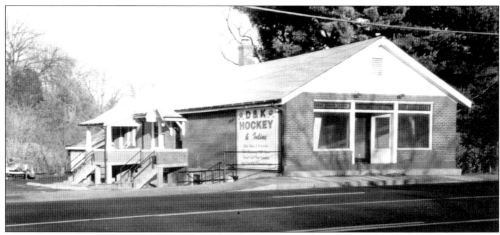

D & K Hockey & Inlines moved into 2427 S. Brentwood Blvd. after Roth Floral relocated. This building was originally the Brentwood Bank.

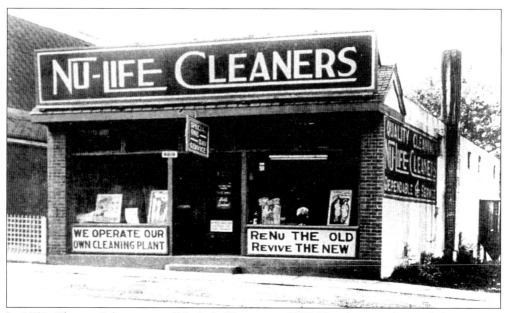

In 1950, Chester Sale, owner of Nu-Life Cleaners at 8818 Manchester submitted the winning slogan for Brentwood. The slogan was, "Brentwood: The City With A Future." This slogan represented Brentwood and its growth until 1969 when a new slogan was chosen as part of the City's 50th anniversary celebration. The new winning slogan was submitted by eighth-grader Debra Ralston of Salem Road. The slogan was, "Brentwood: The City With Warmth."

This building at 2944 S. Brentwood Blvd. was the site of the original Litzsinger Barber Shop.

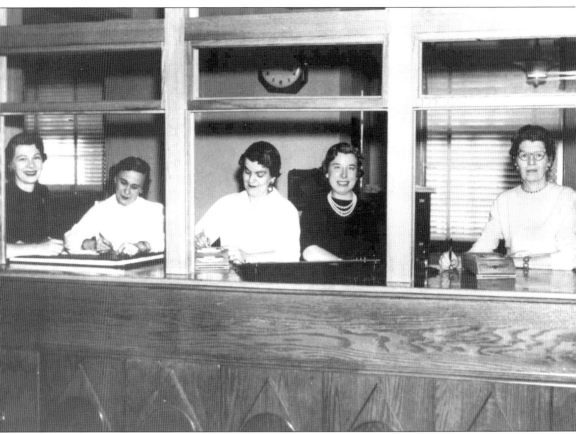

The business of the City of Brentwood was handled by the capable 1950s city hall staff. Pictured from left to right, are Helen James, Sue Shelton, Bernice McAnany, unidentified, and Anne Schall. Anne Mesko Schall spent a major part of her life in Brentwood. She and her husband, Charles, raised two daughters, Shirley and Betty. Anne, who loved Brentwood, contributed to the community by serving as a public official for many years. The Aldermen appointed Anne Schall the city clerk in 1943. Two years later, she was elected as Brentwood tax collector, a post she held for 32 years. After her retirement, Anne worked as a City tax consultant for three years.

In 1969 Anne served as co-chairman for the City's celebration of the U.S. Bicentennial and also helped create the Maddenfest celebration, which became an annual event (now known as Brentwood Days).

In 1974 she received the Rotary "Service Above Self" award. The Brentwood Chamber of Commerce named her "Citizen of the Year" in 1982. Anne loved her wonderful girls, their families, her iris, and her town and its people. Anne had been designated as the official historian in Brentwood. While working with the students and seniors on a 1982 history project, she became interested in forming a historical society. However, before this could happen, Anne died in December 1984. The many people who loved her promised that there would be a historical society, so on January 1985, the Brentwood Historical Society was incorporated. Anne Schall's dream became a reality. Through the society, the people of Brentwood will always remember Anne.

Six

CELEBRATIONS
AND RECREATION

There is a yearly celebration called Maddenfest, which started in 1969 and was supported by a volunteer group of citizens. It was named after the original village of Maddenville. Within the past four years, it is now organized by City employees. The Parks and Recreation Department has been a wonderful source of recreation for the families of Brentwood.

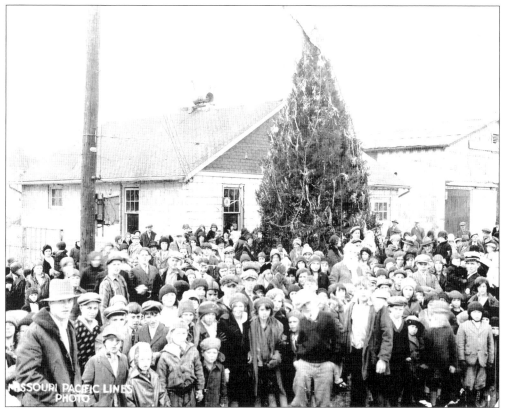

The first community Christmas party held in 1929 in front of city hall at 1115 North and South, now Brentwood Blvd. Each child was given a bag of candy by Santa Claus.

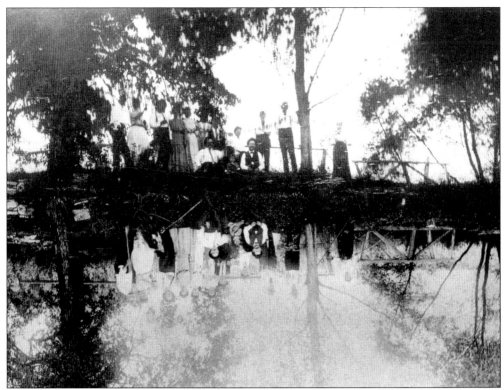

A fishing party tries their luck at Moritz Lake between White Avenue and Moritz Avenue in 1907.

At the Barlow family celebration, guests play croquet in the backyard of the home at 8754 Rosalie, c. 1913.

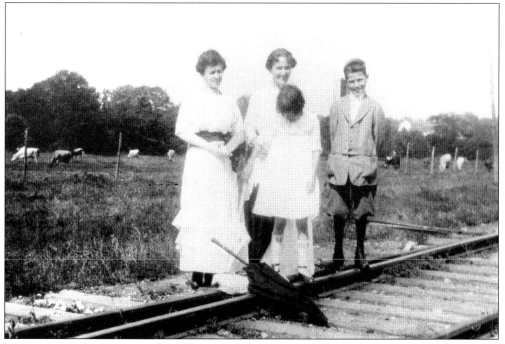

Brentwood Park was originally Clay's Dairy, as seen in this 1915 photograph. The people pictured by the railroad tracks are unidentified.

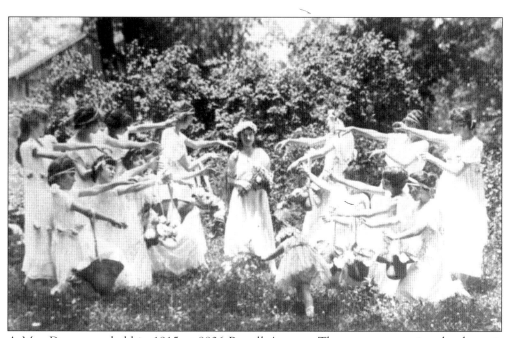

A May Dance was held in 1915 at 8806 Powell Avenue. The group sponsoring the dance is unknown. Pictured are Edna Auer, Frances Bell, Loraine Dougherty, Threasa Silverman, Anna Willming, Laura Lischle, Mary Hobbs, Marie Moritz, Rosey Schmith, Patty Smith, Mabel Doyle, Estelle Schulte, Marie Moss, Catherine Spratt, and Urdine Megin.

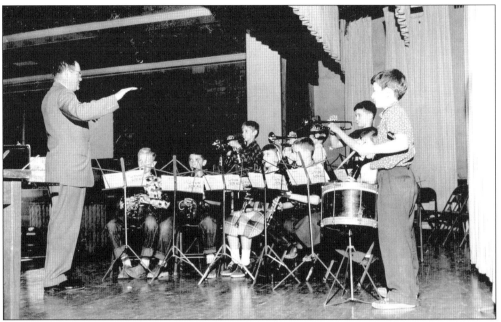

An elementary school band concert was held for all to enjoy sometime in the 1940s.

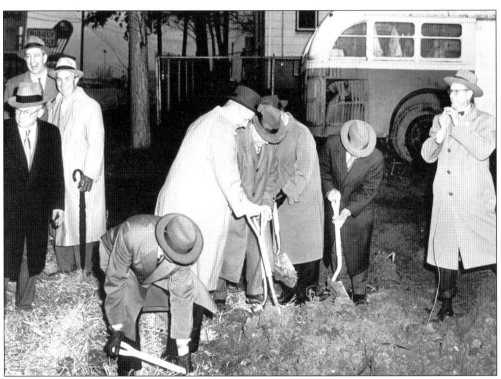

A groundbreaking ceremony was held on February 3, 1957, for the new County Branch YMCA being built on Urban Drive. Pictured from left to right are Robert Willis, Ray Siler (Metropolitan Board), Ray Parker (Mayor of Brentwood), Robert Parker, Robert Vernon, Arthur Froeckmann, unidentified, Alex Hope, and Harold E. Roberts.

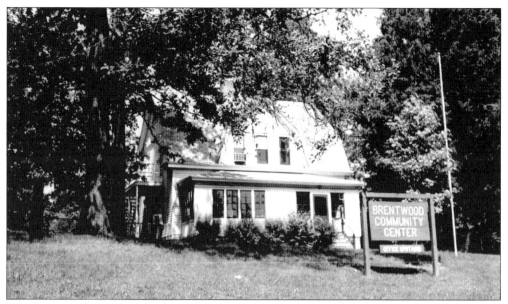

The Brentwood Community Center at 2443 Annalee was purchased by the Brentwood Parks and Recreation Department in 1958 to house general offices and support activities. The building had been the family home of Reverend Stephen M. Pronko, minister of the Brentwood Congregational Church.

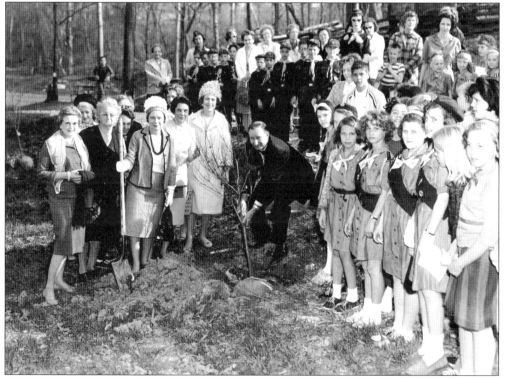

Mayor Ed Wright is shown planting a tree at the Annual Arbor Day celebration, c. 1960s. Members of the Garden Clubs, Boy Scouts, and Girls Scouts also participated in the ceremony.

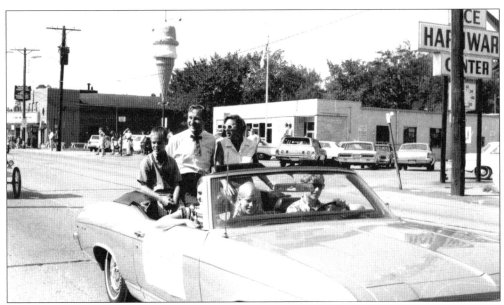

Mayor Ed Wright, his wife, Sue, and Jeff Wright ride in back of the car in the City's 50th anniversary parade in 1969. Doris Wright sits in the center front seat as the parade traveled north on Brentwood Blvd. The Brentwood Theater, post office, Velvet Freeze Ice Cream Cone, and Ace Hardware are in the background.

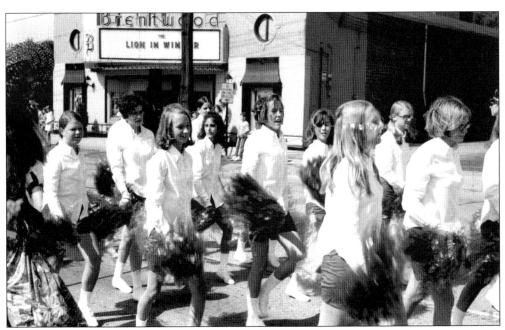

The Brentwood Pom Pom Squad marches in the City's 50th anniversary parade in 1969. Girls are marching north on Brentwood Blvd. past the Brentwood Theater.

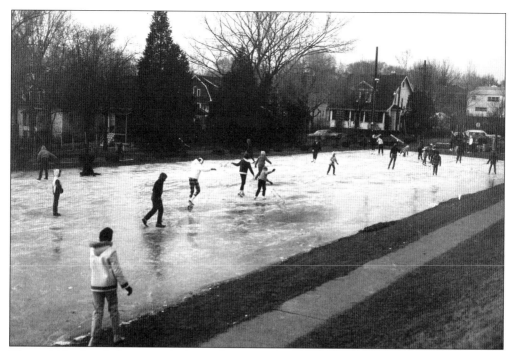

The neighborhood skating rink, located in a residential area, is the grassy area near Rosalie between Dorothy and Helen where the streetcars used to run. The fire department filled the area with water during freezing weather. This picture was taken prior to the building of the Community Center and Skating Rink in 1973.

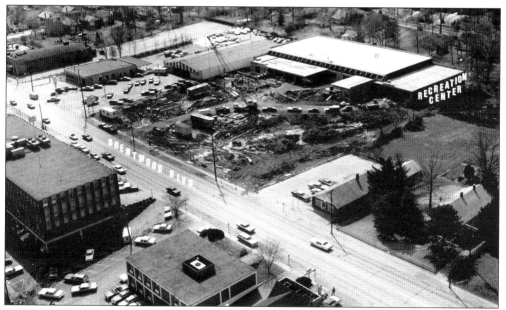

The Brentwood Recreational Center was completed in 1973. It included an ice skating rink that was used as a practice facility for the St. Louis Blues Hockey Team.

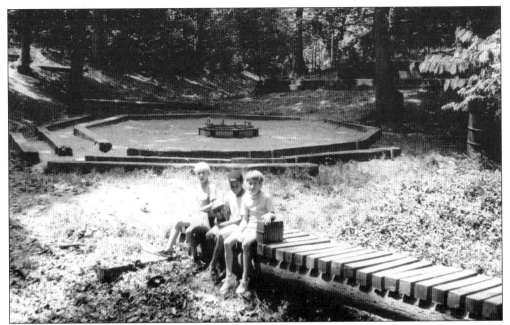

A few friends relax near the fire pit at Buder Park (now Memorial Park) in July, 1971.

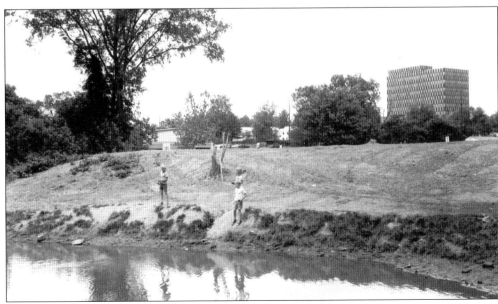

Pictured is the lake in Buder Park in July, 1971.

These Maddenfest or 60th anniversary participants in 1979, pictured here, from left to right, are Art Oppenheim, Candy Cullivan, Jim Willingham (seated), Laura Dilthey, and Anne Schall.

Attending either the Maddenfest or Brentwood's 60th anniversary in 1979 are, from left to right, Gene Dodel, Lucille Marintette, Laura Dilthey, E.R. Michener, Lorraine Krewson, Marcia Pace, and Anne Schall.

The cast of Mark Twain Elementary School's play, "Electric Sunshine Man," are pictured here in 1979, from left to right, as follows: (front row) Tina Sicilia, Rebecca Welsh, and Cindy Camp; (back row) Debbie Ketterer, Tina Katunar, Lisa Tobias, Tammy Gahr, and Diane Bush.

Brentwood High School students rehearse for a play. Students in the Drama Department perform two plays annually, which are available for community viewing.

Regina Gahr and Barbara Gill dress as "Doughnut Dollies" at the Mark Twain Elementary School World War II Night in 1991. Mark Twain School started the WWII project in 1991 to honor the 50th anniversary of WWII. Mark Twain School holds the distinction of being *the first elementary school in the nation* to be designated as a World War II Commemorative Community.

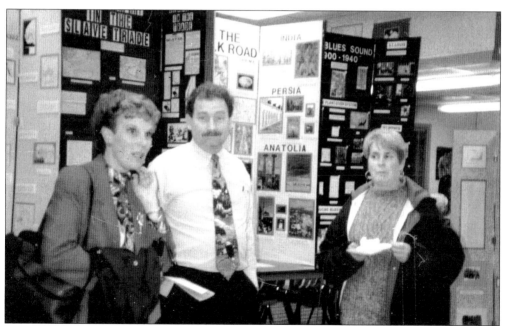

Brentwood High School holds a Student Achievement Fair each year for the community to view the accomplishments of the secondary students. Pictured in 2000, from left to right, are Gail Downs Thomas, elementary school librarian; Chris Corley, high school principal; and Charlotte Ellis, school board member. The history boards that students prepared for the annual History Day competition are pictured behind them.

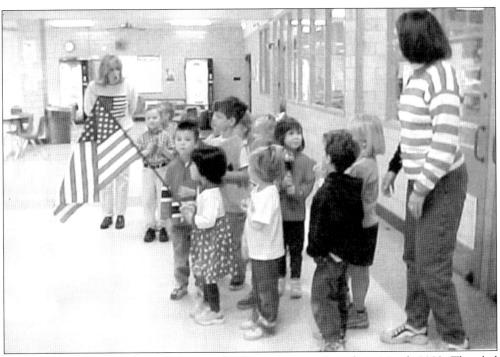

Students from the pre-school perform at the Senior Citizen Brunch in March 2002. They led the Pledge of Allegiance to the flag.

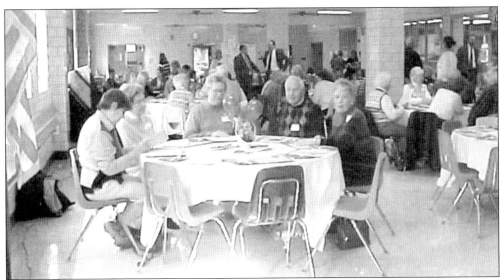

Senior citizens enjoy a brunch given for them by the school district to thank them for their support and to bring them up-to-date on what is happening in the school district. The citizens enjoyed entertainment by the middle and high school students, as well as the pre-school. Brentwood became a City so citizens could have their own school district. Today, the City continues the tradition of caring as the youth and the senior citizens celebrate at "school"!